Copyright © Durva Gandhi, 2012
Breathe Arts

ISBN-13: 978-1479173716
ISBN-10: 1479173711

No part of this publication may be transmitted or reproduced in any form or by any means without prior permission from the publisher.

Every effort has been made to contact copyright holders. We apologise in advance for any omissions and would be pleased to insert appropriate acknowledgement in subsequential editions of this publication.

Editor: Panna Saroopa
Design: Refresh Design Thinking
Photo Credits: Vadehra Art Gallery, Breathe Arts

"SECRETS OF THE ART MILLIONAIRES"

Empowering You
to become Abundantly Wealthy
through Art

Durva Gandhi

www.breathearts.com

Jagannath Panda

BREATHE ARTS MISSION

Breathe Arts is an award-winning online art platform that showcases and sells works of Indian art to a global clientele. Our mission is to empower people financially through Art. We work with artists, galleries, collectors, investors, consultants, critics and curators, helping them evaluate, buy & sell and/or lease their works through our online platform, or privately through our global network.

We are committed to empowering you financially by way of sharing our knowledge and expertise on the Indian Art market in an unbiased way.

www.breathearts.com

IN GRATITUDE

"It is not necessary that every man should be an artist. It is necessary that every man should have his artistic faculty developed, his taste trained, his sense of beauty and insight into form and colour, and that which is expressed in form and colour, made habitually active, correct and sensitive. It is necessary that those who create, whether in great things or small, whether in the unusual masterpieces of art and genius or in the small common things of use that surround a man's daily life, should be habituated to expect the beautiful in preference to the ugly, the noble in preference to the vulgar, the fine in preference to the crude, the harmonious in preference to the gaudy."

SRI AUROBINDO (1872 – 1950)
Indian nationalist and philosopher

> The writer, when he is also an artist, is someone who admits what others don't dare reveal.
>
> LIA KAZAN (1909-2003)
> American writer, actor and director

PRELUDE

WHY YOU SHOULD READ THIS BOOK

'Secrets of the Art Millionaires' is written with the intention of revealing and demystifying the hidden truths of the art industry that have been the best kept secrets for ages. These secrets have been kept under wraps by some in the industry, who fear that if everyone knows the inside workings, they will have the same chances of getting rich with this powerful knowledge.

Some fear competition and feel that they arrived at this knowledge after years of experience and hard work, and sometimes, after spending a fortune buying art and

making expensive mistakes. 'Secrets of the Art Millionaires' is a breakthrough in understanding the workings of the Art Market. Through it, I will show you how to instantly improve your 'bottom line' by exposing you to the inner workings of the industry.

I write from my own experience and none of the insights are good or bad - they simply reflect my experience and the amazing results I have seen after applying these universal principles. If you want to further your knowledge and use it to your advantage, don't just read this book - read it like the Bible of Art it is. This book will bridge the gap between your desire for success and your achievement of success in the art industry.

I firmly believe that unless we can get past our own opinions and egos, and come from our highest, deepest and sincerest selves in the process of making, showing, buying or selling art, we will never get the numbers we are struggling for.

At Breathe Arts, our mission is to help people become abundantly wealthy through art. We empower artists, galleries, institutions, consultants, investors, collectors, writers, critics, curators, art students, and art lovers, with knowledge; bringing about clarity in understanding and a change in attitude by replacing negative ways with positive.

The strategies discussed here are applicable to any economy you choose to play in. Ofcourse, research is necessary for you to know your market, the players and the variable factors at play well enough to be able to make money. For convenience, we will refer to the examples from the Indian art market scenario (my area of expertise). However, you can implement the same strategies in any art market if you follow this advice, word for word.

If you're reading this, then this knowledge is for you. It was written with the intention of reaching various categories of people within and outside the art industry. First, read the section that most appeals to your current status in the market and then move to the others. Outsiders could follow the sequence of the chapters because they will give you a chronological understanding of all the aspects of the industry.

If you're not from the industry, remember success speaks the same language globally - whether you are in art, music, real estate or stocks. A market operates in similar ways across all industries and geographies. If you understand the workings of one, you may quite simply apply the same expertise to any other market.

This book will appeal to you whether you're an art lover or an art geek, an art enthusiast or an art enthusiast in denial. Even if you're

simply averse to the subject of art, the subject of making money may still appeal to you. Dominating your chosen niche might be tough in an overcrowded industry. However, the art industry is still developing, so if you are at a crossroads in your career, or want to invest in alternative assets or just want to read for fun, this book will speak to you.

I hope you enjoy reading 'Secrets of the Art Millionaires' as much as I did writing it. I trust that it will spark something valuable each time you read it.

Happy reading!

> An artist is not paid for his labour but for his vision.

JAMES ABBOTT MCNEILL WHISTLER (1834–1903)
American-born, British-based artist

Anju Dodiya

FOREWORD

THE CURRENT ART MARKET SCENARIO

Following the recession, there was a decline in interest, demand and recorded sales of art globally. Galleries and auction houses agree that not enough people line up to buy the value they provide these days.

We, at Breathe Arts, genuinely want to add value to the industry and build up market confidence by creating a supportive online platform that showcases, sells and helps people become abundantly wealthy through art, by sharing our knowledge and expertise in the industry in an unbiased way. The art world needs more enthusiastic supporters and buyers to collaborate and move the market in the right direction.

At Breathe Arts, we believe the way to empower you financially is by revealing honestly and with integrity the Secrets of the Art industry, so far known only to a privileged few, so that you too can use that knowledge to your advantage.

This book aims to provide lucid information because clarity gives the power to act, while knowledge demystifies false notions. This will lead you to a greater understanding, giving you the edge required to make informed decisions for buying, selling or starting your collection. We hope that these secrets will empower you emotionally, mentally, financially and spiritually.

This is one of the first, if not the only book on Art Investment and is meant to show you how to make money through art. Enough people are talking about the aesthetics in the art practice, but this only serves to make it more obscure and difficult to comprehend for outsiders. The industry or the government may laud these intellectual observations, conversations and solutions, but rarely does anyone talk about what everyone really wants to know - what you need to know. So here goes.

THE OPPORTUNITY

WHAT'S IN IT FOR YOU?
While the recession is terrible for various reasons, it does throw up more buying opportunities and great deals, which were totally unavailable when the market was on its way up. For instance, you can now get great deals because many motivated sellers want to sell their portfolios. Auctions too, are useful for finding great opportunities. In fact, for the first time in many years, the secondary market is throwing up more opportunities to buy at better than primary market prices.

This, then, is an opportune time to consider the various options available, before the market gets crowded again. The Indian economy is growing and with it, Indian art will definitely boom - it's just a matter of time.

THE INDUSTRY PROBLEM

INTEREST
I often meet people who wonder why there is such little demand and interest in Indian art while people flock to catch a Bollywood film or even to the new restaurant-next-door. Has anyone wondered why there are no queues outside our museums and institutions? Is the art fraternity partially responsible for this?

INVOLVEMENT
Everyone realizes we need to connect to new markets and diverse audiences, and move outside the fraternity but no one seems to do anything about it. Is this because of the insignificant value addition for the final viewer or buyer in the entire sequence? Have you ever felt alienated in the art industry? The many buyers I have interacted with feel uncomfortable and almost clueless about the workings of the market. This book seeks to address and change this.

RELEVANCE
The larger role of Art is, without a doubt, to educate people and make them aware of the relevance of what is being shown, as well as the options, opportunities and obstacles out there. However, the industry appears to lack transparency. I can't help but wonder whether we have perhaps become extremely arrogant and elitist about the arts? Perhaps there is some disconnect between what galleries think they deliver as value and how consumers perceive this value. I often wonder about the superficial exchange that exists on the surface at openings with no serious attempts to touch, to connect and to care for the viewer's aspirations, fears, and vanities. Could these be some of the reasons why we have such few buyers and only sellers in the market?

ATTITUDE

The fact that art shows and galleries get only a handful of visitors could well be a clear indication that museums, galleries, curators and artists are so full of themselves that they don't really think about what the audience wants. Perhaps they only create and show works that cater to their own self-promotional agenda and their own sensibilities. Unfortunately, most often, their arrogance gets the better of their intent to serve the greater good of the industry on the whole.

The problem with this thinking is that it is too centered on personal opinions and biases. In the process, the industry insiders have not only forgotten their own higher purpose, but also lost the viewer or the buyer. They have taken the viewer for granted, as if to say, "If you don't understand this artwork, it's because you are not intellectual. Anyone who is intellectual understands it." It is a war of opinions and no one wins because each one is only interested in his myopic vision of pulling the others down.

To succeed, it is the responsibility of any institution, gallery, curator or artist to know his market place, connect with it and understand what it wants and then get involved in making or showing art.

WAYS TO BEAT THE RECESSION

Have you wondered why there is infinite wealth in the universe, enough for each one to live abundantly and yet some struggle to make a living while others thrive? Have you wondered why the 'broke' are the way they are?

The answer, my friend, is this: The universe will deliver to you the exact amount of value you deliver to the market place. Through this book, I will show you how investing in art is not only easy, but also fun, unlike the more serious investment strategies needed in the stock market and real estate. This asset class also comes attached with a prestigious lifestyle element.

The Indian art market has a turnover of US$ 2 billion, and if your temperament seeks to enjoy the investing process and spend luxurious hours researching the market, art is your best bet for both profit and pleasure. You could stop by your local galleries every Saturday, like most collectors, to see what's on, attend talks by experts and meet artists at openings to understand their creation.

Many of you might wonder that if the Indian art market is turning over $2 billion, why aren't people waiting in line to see what the galleries offer? Why there are very few buyers of Indian art?

I have thought about this question and for a very long time I too was deluded. Initially I thought that there are very few people with a great aesthetic sense and that the love for culture and art isn't for everyone. But later I realized that the gap was the information, and the access to the information was only possible for an insider. So I wrote this book to empower you and bridge this gap with this valuable information.

The minute your emphasis shifts from 'me and my work' to 'How my work and I can contribute to you', the whole game changes. This shift in your inner attitude is the game changer! It is the same difference as saying, 'I want a lot of money' and getting stuck with thinking wishfully all the time about a number, instead of focusing on the value you are creating through your work. If you don't like the fruits, you can't change them; you have to make changes in the roots - where the fruit came from i.e. the thoughts, the actions and the process that created it.

Through this book, I look forward to sharing the Universal laws of abundance, attraction and affluence that work powerfully if applied with the right intent. The right intent goes a long way in changing attitudes, replacing negative ways with positive and bringing more of what you want into your life. To my mind, an inner shift in intent is all it takes to change the whole game. It is probably the only underlying factor responsible for the recent shift of power from the west to the east.

CONTENTS

Chapter 1 THE BEST KEPT SECRETS FOR ART GALLERIES, CONSULTANTS AND INSTITUTIONS

ATTENTION ART GALLERIES, CONSULTANTS & INSTITUTIONS!

Page 4 ONE
- How to make Stars out of Artists
- How to create an exhibition Calendar that gets Star Rating, Publicity and Eager Buyers
- How to create an Exhibition Calendar with all SOLD OUT! Shows

Page 12 TWO
- How to Educate Buyers and train their Eye
- How to Educate Buyers and Win Friends
- How to Influence Trends
- How to Show Artworks and Influence People

Page 19 THREE
- How to Sell your Artworks Privately in Secondary Markets
- How to Promote your Artists at Auctions
- How to Promote your Artists at International Fairs

Page 25 FOUR
- Closely Guarded Secrets on How to make a Million Dollars Buying and Selling Art

Page 28 FIVE
- How to Attract Visitors to your Gallery Effortlessly
- Attracting new clients in any economy
- 'Obvious' sales secrets for art business owners and consultants

ATTENTION CURATORS, CRITICS & WRITERS!

Page 34 SIX
- Take the Guesswork Out of Curating and Create a Stunning Show

Chapter 2 THE BEST KEPT SECRETS FOR COLLECTORS AND INVESTORS

ATTENTION ART COLLECTORS & INVESTORS!

Page 44 ONE
- How passionate are you about your Art?
- Can you spot these common art-buying mistakes? Do NOT Buy Art Until You Read These Facts
- "How I made a $10,000 mistake!"
- If you have already bought art, then don't read this. It'll break your heart.

Page 52 TWO
- How to build an Art Collection without spending a Fortune
- How to Protect your Interest when buying Art

Page 57 THREE
- How to make a Million Dollars in Art

Page 62 FOUR
- The Truth About Bargain Hunting: How to get great deals on your art purchases
- How to fill gaps in your collection
- Take the Guesswork Out of Selling Art
- Negotiations in A Slow Market
- Setting the Right Price
- Private Sales Explained

Chapter 3 THE BEST KEPT SECRETS
 FOR ARTISTS

 ATTENTION ARTISTS!

Page 73 ONE
 • Who wants to be a Star Artist?
 • How to become an insider
 • How to map your career as an artist
 • Be a Patron

Page 84 TWO
 • How to handle Criticism
 • How to continue painting without worrying about paying your bills
 • How to avoid Common Mistakes when putting up your Exhibition
 • How to get your artwork into a public auction
 • How to get a SOLD OUT SHOW every time!
 • How to keep your Demand and Prices on the Upswing
 • Artists who make art faster than it sells

Page 96 THREE
 • How to Pre-qualify your Audience
 • How to get an enthusiastic response - even critical acclaim - every time you show

Page 103 FOUR
• How to triple your sales

Page 106 FIVE
• How to Communicate your Unique Message

Page 110 SIX
• How to Sell Art from Your Studio - Nine Tips that Work Wonders

Page 114 WHAT BREATHE ARTS CAN DO FOR YOU?

Page 127 ACKHNOWLEDGEMENT

Page 130 THE ART MILLIONAIRES CLUB

Why can I not lecture in the dark?
Why do people want to see my face?
There is no reason why the audience
should want to gaze on the features
of an old man like myself.

Atul Dodiya

Chapter 1

THE BEST KEPT SECRETS FOR ART GALLERIES, CONSULTANTS AND INSTITUTIONS

ATTENTION:
ART GALLERIES, CONSULTANTS AND INSTITUTIONS!

> The aim of art is to represent not the outward appearance of things, but their inward significance.

ARISTOTLE (384 BC - 324 BC)
Philosopher

ONE
ATTENTION: ART GALLERIES, CONSULTANTS AND INSTITUTIONS!

HOW TO MAKE STARS OUT OF ARTISTS

The first step is to identify the right artists to show in your gallery. An impeccable aesthetic eye with a keen understanding of the market and knowledge of global trends are usually the starting points to spot the right kind of talent long before the world sees it.

Next, influence the market to see a promising artist the way you do–why you picked him and why you think he is the next big thing. This then becomes your story, the artist's story and the story for the exhibition.

Your success as a gallerist depends on how many people in the market you are able to influence with this story. You are the link between the artist's expression and his work and the market or the ultimate buyer.

Having said that, it is imperative that your story be an honest account of your own experience when you first saw the artist's work–dramatic, overwhelming and credible are important milestones to reach. The clarity of communication and the right language to describe this experience will then serve to connect the artwork to the buyer or the market.

While curators can help you with this process of communicating, you need to spend time letting them know what your story really is. Sometimes, curators get lost in obscure words and forget that their role is to bring out the artist's expression and connect it to the market. This could be why most buyers find it hard to understand the artist's language. The story can lose its purpose of connecting to the market. But, and I can't

stress this enough, instead of closing the market by making it too exclusive, we need to focus on keeping it simple and inclusive because, as we all agree, there is a dearth of buyers in the Indian art market. The curator's job in this situation is to facilitate the all-impotant dialogue between the artist and his market.

The market is most interested in this part of the story - 'Why do you think this artist has great promise?' because this will determine his future potential value for a buyer. The buyer will use this information to interpret whether the artist or a particular artwork is a good investment or not. Of course, a gallery or curator's credibility counts. Past experience, track records of success and testimonials by collectors who bought based on a gallery's advice and saw a huge incremental value on their collection over time, will build confidence in the market.

If you don't have a lengthy track record, then your commitment to your stable of artists, the process and the strategies you employ to promote them and make stars out of them, will determine your influence over your market. You need to be transparent and to try harder to make yourself and your intentions heard and believed. The market demands integrity in what you say and do. Do you walk your talk or do you just talk?

For example, you think an artist is great and has great promise and feel that someone must buy his work. The buyer will want to see if you have put your own money where your mouth is before you can convince him to spend his money. He wants to see your potential in driving the market up. If you have no experience, he knows he can choose from other more experienced vendors. So again, transparency and dignity in your code of conduct are vital, as is sharing your views on why and how soon the artwork's value will be upward bound. The buyer needs to know your estimate of the market's size for that particular artist in both, the immediate and distant future.

Once you have got the right artists, the right attitude and the right timing, then you will have the right influence over the market. This means you will become an influential trendsetter and can dominate your niche. Once you are in that place, your artists and their stories will be heard and they will become stars.

So, for your artists to become stars, first you and your business need to become stars. You need to be in a position to influence the market and its trends: so work on yourself, your business, your processes and, the rest will automatically follow.

HOW TO CREATE AN EXHIBITION CALENDAR THAT GETS STAR RATING, PUBLICITY AND EAGER BUYERS

Synergy among your curator, the artist and your institute will create a story about the exhibition and the artist. Your job then is to organize a press preview for the show before it opens to the public, where all three parties are present and where media interaction can take place alongside the artwork. Basic queries about the work, the artist and the gallery's interest in it - the story, basically – should be answered here. Those interested in in-depth stories can fix appointments with the artist, the gallery, the curator or all three depending on their angle. A professional approach to the media, with the help of a reputed PR agency can help you get the best coverage.

In the art world, market perception can be everything. How people perceive the gallery, the brand and the artist determines if they consider an invitation worthy of their time and attendance. An average buyer or journalist today receives up to 10 invitations per week from galleries, auction houses, artists

and other assorted events. Many choose not to venture out to galleries any more, unless there is an important, interesting opening. If your show does not register significantly in the minds of potential buyers and circles that count, then you will not see the expected footfalls.

It might be worthwhile to consider a joint venture with other popular, high quality events. For example, open your shows during the Kala Ghoda festival or time them with other important openings near the gallery, where the people who matter are expected to show up. In an ideal situation, yours should be the event that they come to, but unless you have that hold over your market, the turn out might be disappointing.

For example, on 'Art Thursdays' many galleries decided to stay open much later than normal. They invited all their buyers with a single invitation instead of scattered individual events. This was successful because more people showed up. New galleries may have benefited more than the established ones but, all in all, everyone got additional traffic on a single Thursday.

One way to come up with innovative themes and share them with your market is to develop excellent media relations, and look into potential pegs for journalists to cover your unique story or your wonderful show. But, your story needs to be interesting! Only then will the media be eager to come to your space in the first place and then feature it in their columns. You, the artist and the curator need to assign one spokesperson for the entire event. This should be done professionally: images splashed across Page 3 or in trivial publications do not go a long way in establishing your content, its seriousness and its value.

Work at getting the right message across to the right media or they will publish only what is immediately visible at the opening. You are your own spokesperson and so your script needs to be

written and rehearsed in advance. It seems like common sense information that everyone knows, but alas, few seem to be doing it well! There are thousands and thousands of media spots for art and either you hire a dedicated in-house communication executive to do this job on an ongoing basis, or engage an agency to do this for all your events.

HOW TO CREATE AN EXHIBITION CALENDAR WITH ALL SOLD OUT! SHOWS

An 'All sold out' show means people are waiting in line to buy the value you have to offer. To get into this appealing situation, you need to have great influence over your market, discern the pulse of current trends and be in the know about what the market really wants. If you can find this out, then all you have to do is get it and offer it! This sounds simple but despite knowing all this, most people still do not do what they ought to.

There are three types of people in this world: Those who don't know; Those who know, but don't do what they know and Those who know and say they will do what is needed, but don't do it. Now that you're reading this, you obviously know you need to do what you know, and to do what you said you would do!

So if you know that there is a demand for a particular artist's work, why not get a body of his works and just show it? Most people don't spend time pre-qualifying their exhibition calendar; they just handle whatever arrives on their table and hope to get by. They do not research market trends, auction trends or pricing trends. They do not time their exhibitions properly or fill their calendars profitably or utilize pre-qualified mailing lists. This is a rookie mistake.

An all sold out show demands some research, market analysis and market acceptability, and pre-qualifying buyers for each work in the show. Your exhibition calendar should fit this research criteria and information. For an emerging artist/group, you need to get into the buyer's mind to see if YOU would buy these works. What price would you pay for something like this? What do you consider this artist's future potential to be? Will his works fit in your own space? Examine how hot you really think this art is. Are you just filling up your space and calendar or do you strongly feel this artist is a genius? All gallerists feel they could create a demand for whatever they want to sell and make stars, but that may not always work in the current economy. If you findout what the market wants and base your calendar on this research, your chances of success multiply.

So, get a sense of what buyers may think before you experiment. Crosscheck this with close, knowledgeable confidants instead of setting yourself up for a rude shock after an expensive exhibition. Of course, much that is in demand has already been taken over by the more established gallerists, and creating a new market will take time and resources.

The rules of the game have also changed in the present market. To have an all sold out show, you need at least 5 ready buyers for each artwork in your gallery at every point in time, no questions asked.

Consider pricing the works lower than the market to get more people interested in your proposition because everyone is looking for value. Try rethinking your tried and tested ways of doing things. If they aren't working, adapt to more innovative, effective methods.

If you had 20 works in each show and 8 shows a year, you need to pre-qualify your buyers for each show and reach 800 buyers each year to have an 'all sold out' show every time.

If you already have a gallery, and feel this figure is too much, then just show as much as you think you can, for it to be all sold out. For example, if you have only 200 buyers, then you can only sell 40 works, and you should only do 8 shows with 5 works each, or 4 shows with 10 works each year, or 6 shows with 6 to 7 works each for the year.

You need to know your market size, your ability to influence that market and plan your exhibition calendar accordingly. Your ability to succeed as a gallery will depend on these factors.

So do not avoid this simple calculation before you get into business or if you are already in the business. If you don't have that reach then it might not be worth your while to start a new gallery. By reach I don't just mean a 1000 people on your list! As a gallerist, you should know that the rule of the thumb is you sell only 20% to 40% of what you show in the opening week. So if you wanted to defy this normal scenario and aim for an all sold out show, you need 800 people to buy from you each year and 4000 people who like and trust you enough to buy from you at your openings 8 times a year.

TWO
ATTENTION: ART GALLERIES, CONSULTANTS AND INSTITUTIONS!

HOW TO EDUCATE BUYERS AND TRAIN THEIR EYE

As we discussed, your influence over your market is your key to success. A simple enough notion, and yet I choose to repeat this but even though it's an obvious fact, it is not apparent to most people who, despite knowing this, do not act on what they know.

When I say influence and educating the buyer, it is not about manipulation and getting someone to have your exact opinions. It is, in fact, a way of understanding the buyer's individual processes, his desires and aspirations. It is helping him find and develop his own sensibility even if you don't like what he begins to like in the process. If you try to manipulate and claim that your artists are the only ones and will provide the best value in the world, chances are a buyer will sense your bias and shy away.

Instead, if you help someone connect with his own unique visual language and let him develop his own taste and share your opinion objectively about the top 10 galleries and their top 10 artists, etc, and let him explore the whole art scene, chances are he will keep returning to you because of your honesty and objectivity.

If your buyer does not have your taste, (which is very often the case), then you may need to train his eye. This does not mean influencing him to buy the artists that you promote exclusively. First educate and understand him and get his attention. Don't be in a rush to sell the very first time a potential buyer walks in.

If you try to push him into buying what you want to sell, without understanding his interests and connecting with his aspirations, you may make a quick sale, but you will lose his trust. People only buy from people they like.

So it is important to train the buyer's eye with objectivity, and in his interest and growth, not just for a sale. Most galleries are slapping their displays and artists on people whether they are interested or not. The point here is that, if you can shift your intent and perspective just a little by asking how you can add value instead of focusing on selling an artwork, the whole game changes. Remember, the universe will deliver to you the exact amount equivalent of the value you deliver to the marketplace.

HOW TO EDUCATE BUYERS AND WIN FRIENDS

You are the link between your artist and your market. You may be touched by the artists you show, but unless your market or your buyer see your artist and his work in the same way, you will have little success. The clarity, honesty, integrity and delivery of your communication determine how the market receives this artist and your story.

Whether buyers believe you or not depends entirely on your credibility and trustworthiness and whether they buy into it or not depends on the value, future potential and promise they perceive they are getting. Any flaw in these factors means you lose your market or your buyers to other artists or competitors. Today's environment is quite cutthroat and the market has moved from being a seller's market to being a buyer's market. This opens up many choices for buyers in terms of who and what to buy. You need to be clear upfront about answering why buy this artwork or this artist and why from you in particular.

The way to win friends is by educating the buyer, being unbiased and ready with an honest opinion every time he asks for one. If you have been manipulative in the past by passing off average work by an average artist as great work, you have lost his trust already.

On the contrary if you have been honest and spoken in a buyer's interest alone, chances are he will be more likely to buy on your word at some point.

In the recent past, things were different, in that it was a seller's market and sellers were choosing whom to sell to. Not so anymore. So adapt your sales strategies to the needs of the changing market to stay on top. Flexibility in order to acquire market share and to keep a buyer happy are the keywords today.

Some may disagree, but arrogance will not work in your favor. The market can be harsh, buyers might purchase from you if they really want a particular artist's work and you are the only primary market supply there is, but what they want can change in a fraction of a second. They have ample choices and many sources to acquire it from. Thinking of yourself as indispensable is folly, so win friends instead of adding buyers. If you can befriend a buyer, even without a sale, you have gone a long way in building a relationship. The art market may seem very competitive but really, it is quite collaborative. Most galleries that seem to be competing, often work together to fill gaps in their inventories.

HOW TO INFLUENCE TRENDS

Your ability to influence trends in the market determines your success as a gallerist. Here are some ways to reach an influential trend-setting position.

One way is to show cutting edge works and create a much talked about exhibition calendar that attracts international curators and critical acclaim.

Your exhibition has to be artist-led or curator-led, which means your artist or curator conceives the exhibition and also designs and plans it.

When important investors and collectors buy an artist's work and endorse it, he and his body of work zoom into the stratosphere and bask in the hype. Internationally, hype is created by the curator who spots something, which is then seen from a new perspective. This innovative way of looking at something gives everyone the excitement of a great new find. When a curator or an artist leads you through a unique visual and sensory experience within the work, this work may then enter the zone of great art.

If you can shift someone's perspective - and that only happens through experience-then you have created interest and whetted appetites. The person has changed; he is no longer the person he was before this experience: you have enlarged his experiential vocabulary. His interest in art will have a new dimension from this moment. He has been influenced and, from now, is open to more experiences and more art viewing. Eventually you have a potential buyer. All buying starts with getting his attention, interest, and desire, and buying follows this sequence.

It is up to you to get your buyers or potential buyers engaged at all these levels. Do not just slap on a display and go about your business. No wonder most people feel intimidated in a gallery and hesitate to ask questions about the art. They may feel bashful about what they don't know or feel foolish and talked down to. This is bad practice by galleries.

A person could just be your prospective buyer even if he doesn't look like one. Even if he doesn't buy a work right away, he may do so at some point. It is up to you to engage and interest him. Your assistant cannot do this job because most people feel intimidated or annoyed by a salesperson approaching them with a price list when they are just looking to connect with the display.

Once your potential buyer has been touched by what he sees and has all his questions answered satisfactorily, he may proceed to buy or not. That is not the point. The point is his experience in your space with or without you, which determines whether he will come back in the future.

Let's put it this way: To influence trends, you need to influence the maximum number of people. To influence people you need to attract their attention and connect with their interests, desires, and aspirations. This will eventually lead to sales. Depending on their experience with the purchase and how they feel after the purchase and after sharing it with other collectors, they may trust you and buy from you again and again and again. If they feel they got a raw deal, bad service or low quality work, they will never return. So it's up to you to create the best experience for your current or potential buyer so that he comes back to you. Thus, even a prospect will get converted into a buyer.

HOW TO SHOW ARTWORKS AND INFLUENCE PEOPLE

I believe you can influence people by genuinely adding value to their lives and collections; by sharing your talents in serving them and setting the right intent in all your interactions. Helping them get better, and even the very best deals always goes a long, long way in establishing your integrity.

An artist, articulating his own experience and expression has a powerful effect on the audience, provided he is good at communication. A talk with a curator and the artist sometimes brings out aspects of the work that would otherwise remain buried. People first connect with their hearts and then with their intellect. So, your story has to have the right message conveyed emotionally to connect to a wider audience. If you use intellect alone, you will get only the mind space of the market. To win hearts, people need to feel the vulnerabilities and be moved by the human aspects in your story.

Some top artists feel saddened that they do not share the same status as Bollywood stars. This may be because the heart or emotional connection is entirely missing. A Bollywood star cares nothing about looking foolish and playing say, an irrational person in love to get his audience to fall in love with him. He puts aside his own ego or his own self-limiting beliefs and bares himself to his audience. The best stance for an artist is to be true to his self. However, most just keep adapting to a market. If you are adapting to a market script anyway, why not adapt to one that works?

Some intellectuals in the art fraternity may feel, we are above these lowly, emotional 'showbiz folks', and place themselves on a pedestal. Some try too hard to look and sound intelligent and somewhere lose their human element. Unless we can get past our own opinions and egos, and come from our highest, deepest and sincerest selves in the process of making, showing, buying or selling art, we will never get the numbers we are struggling for. Neither artist nor actor is good or bad, neither seller nor buyer is high or low, all are storytellers adapting their stories to global trends or current topics.

"Nothing will have been achieved by museums and galleries unless men's lives are changed by what we have to show.

ANANDA COOMARASWAMY
Art historian

"

THREE
ATTENTION: ART GALLERIES, CONSULTANTS AND INSTITUTIONS!

HOW TO SELL YOUR ARTWORKS PRIVATELY IN SECONDARY MARKETS

Today, most buyers crosscheck with other buyers and friends in the industry before purchasing something. For example, if someone likes a work, research says they will check with 3 to 5 friends in the industry or with collectors who have bought similar works in the past. Asians are value conscious and prefer to make value purchases after checking with family or friends and after some work trying to find the best deals. What this means for a gallerist is that you have to influence your buyer, his acquaintances AND your competitors.

Whether the sale goes through or not is determined by these confidants and the experiences they share with this almost ready buyer. Who do you think these other people are? None other than your so-called competitors!

As I said before, the art world works in strange ways and galleries that seem to be competing are actually collaborating. Stop considering your fellow gallerists as competitors, rather consider them associates and work alongside for a mutual win-win scenario. Instead of slitting each other's throats, it is advisable to work together to create a larger market for art rather than working individually to create a quick sale for yourself. Misinforming buyers and creating negative stories about someone else's artwork and gallery is detrimental behavior, even though it gives you an unfair manipulative advantage. These manipulative practices could be partly responsible for the recent loss of buyer confidence. Instead of multiplying, buyers have diminished in number after seeing

When beginning in a room, search for the focal point or the anchor in each room. According to the APSD® Standards and Procedures an 'Anchor' can be defined as "One defining piece, fixed or otherwise that defines the room. It creates a "focal" point in the room. A great example of this is a fireplace, bay window or an area where you eye naturally falls first upon entering a room. It may also be a showcased piece of furniture such as a beautiful armoire or bed.

Now you can focus on staging that area in order to get the greatest impact out of the room. And depending upon the home, this may be enough staging for that particular room. The additional benefit out of staging the Anchor or Focal Point is it puts the emphasis on a good area and softens a less than desirable area.

For example, we staged a home that had 7 long windows that faced a barren back yard. Now this yard had some serious potential but the owner did not have the inclination or the budget to fix up the back yard or even add window treatments so there it was, big, brown and bare! Instead of placing focus on that area, we chose to use the focal point in the room more effectively which in this case was a fireplace and a nice big four poster bed. We pulled the two areas together to really create a great scene that was sweet, cozy and inviting.

Now I know what you are thinking, 'Yeah Karen that is great but you still have that huge desert- like back yard!" And you are right. The goal is to first get them to fall in love with the home, then disclose or deal with the problem. In this case we did both. We created a great space and really used the Anchor in the room to create impact and then we added a POE, Pockets of Emotion®. That was a breakfast tray, a cup of coffee and a Gardening Magazine.

The magazine had a note written on a really great picture of a fabulous backyard that said "Happy Birthday Honey! This one is all yours! Thanks for waiting. Love, Tom" so now the new owner is completely in love with the property, with 'Tom' and the fact that they can 'see' their new backyard. That is a great way to easily and cost effectively add lots of love to your home.

When you begin to stage, be very, very specific for each and every room.

And, as a recap, as you stage you will create 'Scene's" which are defined as: *A CUSTOMIZED GROUPING OF FURNITURE AND DÉCOR THAT* answers the following 3 questions: 1) Where am I? 2) How do I feel about where I am? And 3) Who belongs here? By doing this, you are personalizing the room for each individual which gives them the opportunity to see and feel themselves living in the home, and of course, to fall in love with the home.

As I mentioned earlier, I used to be a professional actor and I always equate **creating home staging scenes to creating movie magic**. When you enter the scene of a movie, you always know where you are, how you feel about the scene and who belongs there. The same is true with creating a great scene for homes.

Our team created a great 'Tweener' room during a home staging training course I was conducting. A 'Tweener' is a child that is somewhere between a little kid and a teenager and usually falls in the age range between 7-12. You know how persistent that age group can be! But the truth is they are still kids and we want them to feel comfortable and as though they belong.

With this particular home, we took the time to define our buyer and in doing so, we realized that the buyer would have 3 kids, one of which was a 'Tweener' so naturally, we staged one room for them. This room had a bean bag chair, some posters, an MP3 player, and then a few teen magazines along with a few other items.

So when the parents come to look around and brought the kids, there was something for the kids to do which allowed the parents to look and spend time in the home.

As you can see, this is very purposeful. If you don't do this, by the way, you will find a child moping behind his or her parents, saying "Mom, mom, mom, mom, mom, mom. When are we going?' or 'I'm hungry!' And if they bug the parent enough, they will all leave and you are the one that loses, so give them something to occupy their time. Honor everyone that will be living in the house and in this case, it was the 'Tweener.' So the parents were looking, the kid was hanging out in 'his' bedroom listening to music and flipping through a magazine and another family sees cars in the driveway and pops in for a second look. Both sets of adults are walking through the house and the child of the second family automatically walks back to the Tweener room. (This is a great sign because he already feels as though it is his space!). Upon seeing the other boy in the room, the one at the door stops and says 'Dude, that's my room.'

I knew at that precise moment the house would be contracted that day, and it was!

That story is a great example of staging a small room. But, if you have large rooms make sure that your staging doesn't get lost within the room, which is why I said that sometimes you don't need fill a room and sometimes you do. In a really small room, sometimes you can get away with a very simple scene, especially in a baby's room, a laundry room or a bathroom, but sometimes if your room has more space you'll need to fill the space.

FOUR

CLOSELY GUARDED SECRETS ON HOW TO MAKE A MILLION DOLLARS BUYING AND SELLING ART

Identify the right talent with your aesthetic eye long before the market spots it. Then use your influence over your market to create the hype, the demand and eventually the value in your artworks. Your credibility, trustworthiness and past track records will expedite this process and work in your favour.

After identifying the right talent, first tie in the supply with a strict contract or buy the works yourself or with other friendly investors, and then show the works in your space.

Next, find the right marketing channels for representing this artist internationally at art fairs, biennales, international gallery tie-ups, etc. Create a global presence; hoping international investors will buy the works at ten times your original price.

Many galleries have made inroads in the fairs but do not want to exhibit for various reasons. You can tie up with these to show your artists if you are worried about getting entry to the fairs yourself. A strong secondary market presence means that many collectors have works by a certain artist and hence a secondary market exchange can begin.

Auctions houses now come into play. They want to represent artists for whom they see a strong demand. Collectors or investors who bought these works in the past can now sell them at these auctions.

Art Dubai, etc. Of course, this visibility comes at a price, but what it does for you as a gallery, your artist and his work is priceless.

Most international art fair bodies and councils have strict norms of entries and accept only a handful from a large number of applicants. Most galleries find this a rigid barrier to surmount. One way to cross this is to tie up with reputed international galleries or with institutions that don't have the resources or plans to exhibit. You could split your booth space and name title with them and give them a commission on sales.

The other way is to tie up with a local established gallery and split costs. Usually most are happy to do this because it is very expensive to ship works. Sharing costs and space make for a win-win situation for all involved.

The fair bodies and councils have huge concerns about multiple galleries representing the same artists. If a primary gallery represents an artist and another gallery shows this artist's works in its booth, it will be asked to explain or to decline the place or that particular artist's work since it belongs to the primary gallery. So if you consider collaborating with a gallery at these events, do get an official go ahead from the fair or councils in advance and avoid controversies. Collaborating, rather than going solo, is surely a smarter way of doing things. That way you attract other artists, collaborators and buyers to your works as well and vice versa. The lower costs are a huge relief for all!

market and low buying interest. They have built up a market from scratch for their artists and created stars.

So don't get out of line too soon, because when you wait your turn, you can reach the top of the line. To get paid the best, you need to be the best. So focus on being the best at what you do, instead of focusing on the result.

When all these forces are aligned in your favour, it is only a matter of time before your artists' works come up for sale in the secondary market and into auctions where the market decides their price. You may be able to influence this process but it is not always necessary. Organic growth is healthier than quick shortcuts that might not go a long way.

Should you choose to intervene and establish a market price for a particular artist at a public auction, you need to support your artists by buying back their works at higher prices. This might involve serious investments and unless you have a vision and a plan to execute this, it might be a call of vanity.

HOW TO PROMOTE YOUR ARTISTS AT INTERNATIONAL FAIRS

Today, for your gallery to be successful, it is imperative your artists are not just local or regional heroes, but have an international presence on the global art scene. In order to influence global trends, it is essential to represent your top artists at international fairs and biennales and get important critical and curatorial acclaim for their work. To raise the value of your artist and his work, and gain global visibility, show his best, most vibrant works to important international audiences at fairs like Art Basel, Art Miami, The Armory, Venice Biennale, Frieze Art Fair,

HOW TO PROMOTE YOUR ARTISTS AT AUCTIONS

To promote your top artists at auctions and to build a strong secondary market presence, you need to have all the other parameters in place. For example, your artist should have had sold out shows in the past, you should have testimonials from buyers, you should have credibility in your own establishment, past track records of success with your other artists, critical and curatorial acclaim, media success and international art fair and biennale representations.

Auction houses and the market want to see your commitment and confidence in those artists for whom you are creating a secondary market.

Once you have all of the above, then auction houses will welcome you with open arms to the world of secondary market makers. You will then have upgraded yourself to get first class privileges of the movers and shakers of the art industry.

If all these forces are aligned in your favour, then success is yours, my friend. This is a matter of momentum and time. Most often people lose patience and give up when one or the other factor is not in place, be it market support, lack of interest in their efforts, etc. In most instances, they give up just before the finishing line. Like in any other business, success lies in consistency: doing ordinary things consistently well produces extraordinary results.

Large successful galleries like Vadehra, Chemould, Pundole, Nature Morte, Sakshi, Breathe Arts etc have consistently done well and produced extraordinary results, irrespective of the

the losses in their art-related investments. They have moved to other lucrative investments.

Maybe art should not be seen as a mere investment vehicle but then it should not be selling at the prices it does! Since the prices are so high, people are forced to look at it as an investment option. If you bought a Raza painting for Rs. 5 lakh in 1995, you did not care whether the price went up. You might be surprised that it rose, but to expect that kind of repetition at current levels is unrealistic, at least in the immediate future.

To have a vast influence on your market, your artists need a strong primary as well as a secondary market presence. A gallerist can influence a primary market. A secondary market needs some investors to enter your space to build a strong presence at auctions.

Once you have successfully created a strong secondary presence for your artists, you have created value for investors as well as buyers. However, to sustain a healthy market for your artists, you need a healthy balance of genuine collectors and investors. The ratio of 70:30 of collectors to investors is a good one.

Yes, a collector is preferred to an investor. Most galleries insist that they don't want investors but they themselves usually cannot fund secondary market operations. They need investors to create a win-win situation for all. It is important to create the right balance. For the health of the market, it may be best to maintain a balanced ratio of collectors to investors, as they do not flip the works around as frequently as investors. Given this equation, in today's market scenario, we have hundreds of investors and consultants posing as collectors.

This group buys and flips works for a profit but will not admit they are consultants: they want the social privileges and prestige of being termed 'collectors'. Ah, the vanities of the art market!

An artwork that you originally bought at Rs. 30,000/ USD 600 may now be auctioned for between Rs. 25 lakh/ USD 50,000 and Rs 35 lakh/ USD 70,000. If you had bought 20 of these works at that time, your portfolio would now be valued at over a million dollars. Even if you sell these works at prices 50% lower than the market price, you can still liquidate your portfolio for half a million dollars, which is a 1000% return on your original investment. Is that cool or is it cool?

FIVE
ATTENTION: ART GALLERIES, CONSULTANTS AND INSTITUTIONS!

HOW TO ATTRACT VISITORS TO YOUR GALLERY EFFORTLESSLY

As a gallerist, you know that attracting visitors to your space, apart from on opening day, is the most challenging task. Huge overheads and rents do not justify a year-long rental for just eight days of openings through the year. For the rest of the year, your display space is an expensive office premise. Even if you own the space, your space could be making more passive rental income than gallery income in most cases.

Private secondary market sales constitute a large chunk of the revenue and you do not need a huge space. The primary exhibition calendar for most galleries is a cost and effort model, which pays huge returns in the long term but with considerable risk. It depends on international market movements and artist acceptability. With fair participations and biennales, the art business gets ever more cost intensive and competitive.

Today, space is not the only factor; there are many others like media exposure, an international presence, competitors, artists' stability and market growth, which affect the overall performance of a gallery. To top it all, there are so many galleries and such few buyers! No wonder then that 80% of art circulates among industry players. Most galleries compete for buyer and fraternity attention and bringing footfalls to exhibitions has become increasingly challenging.

ATTRACTING NEW CLIENTS IN ANY ECONOMY

It is no longer enough to follow in the footsteps of our artistic predecessors. Those who are succeeding today are not doing the same things they always did; they are trying new things and tapping new markets. That is one of the best-kept marketing secrets.

A customer is someone who has bought from you within the last year, even if it the work was worth the most insignificant amount. A customer goes back to becoming a prospective buyer if he has not bought from you in the last year. Hence you need to keep reinventing your list; to rely on your old list and database is a folly because people who were buying then are not necessarily buying now. It is important to engage new buyers and keep modifying your list on an ongoing basis.

Many galleries and artists are suffering with reduced sales and blaming it on the economy. However, there are other galleries that are selling more artworks than ever. Historically, in a bad economy, aggressive new companies win by advertising while their competitors focus on saving money. Plus, new galleries are becoming ever more visible, thus stealing the older competition's customers, prospective or otherwise.

'OBVIOUS' SALES SECRETS FOR ART BUSINESS OWNERS AND CONSULTANTS

- People buy from people they like and trust.
- Buyers don't just buy your product or service; they invest in a trusted advisor relationship.

- Remember the old saying-Seek first to understand, then to be understood.
- You need to Make it Happen versus Hoping it happens.
- Genius is one percent Inspiration, 99% Perspiration.

Besides these truisms, there are certain art world-related secrets you need to be in the know about.

KNOWING WHAT A BUYER WANTS

You learn to recognize someone's aesthetic sensibilities early on from the way they dress, the works they buy and the artists they like. There's a conceptual realm, a spiritual realm, and then a decorative realm: follow the clues seen in their collection and then point them in the direction of something similar by a different artist. There are different aspects within the history of art and you need to figure out who matches what type of aesthetic.

KNOWING THE DIFFERENCE BETWEEN A PROSPECTIVE BUYER, A GOOD BUYER AND A BAD BUYER

You can recognize a good buyer by his enthusiasm about your artwork. Certainly, someone who wants to come around and look at your work is a very good sign of a good buyer. In order to confirm this theory, it is important to ask questions-maybe not during the first conversation, but on the second conversation or at the time of viewing. For example, you can ask the potential buyer whether he is familiar with the artist's work, whether he has any other works from the same artist from a different period and why he is considering this work. Too many questions during the first conversation can prove a little intrusive to potential buyers.

When it comes to selling your art, I hope you never run into a bad buyer. A typical bad buyer is indecisive. He could be somebody who has already sold some of his own artworks in the past, but

is looking at several others and may be playing one seller off against another. This really is not good news for the seller. A bad buyer is someone who is really not in a position to buy your work. This may be difficult to spot immediately but you will be able to spot it further down the line.

The best way to vet buyers over the phone is to ask and take notes of their names, mobile, work and home phone numbers. Make sure you note their comments about your artworks at the time of viewing.

KNOWING THE INTRICACIES OF BEING AN ART DEALER

Art dealers make a commission by selling art and this commission depends on the value of the artwork. There are different ways of becoming an art dealer. Generally, one does a degree in art history and then works with an experienced art gallery owner to get experience. Alternatively, you can become an art dealer through the auction house route. Or you may work with private dealers who buy and sell art. Primary market dealers work with artists and galleries whereas secondary market dealers work for clients, trade works between themselves and sell to individual private collectors or build collections for institutions and individuals. Like all industries, art has a seasonal cycle. It begins in September and peaks towards the year-end. April and May is a relatively quiet time in the market. Since the world is now the market place, dealers often making exciting travel plans to visit the artwork or the buyer. Being on top of all the local and global trends in the industry gives you the exposure required.

KNOWING WHAT NOT TO DO WHEN SELLING ART

Most people have a tough time admitting they are dealers or sellers and like to be perceived as collectors. Maybe that is their way of getting attention and better information from the market. If the market perceives them as buyers, they are likely to receive more information than if they come across as sellers.

They then might get less attention from the fraternity and maybe the press. A lot of hypocrisy like this exists around 'selling art'. When it comes to buying, some dealers show their faces, but when it comes to selling, they prefer to do it anonymously and use someone else to execute the deal.

What people find most challenging about selling art is accepting their own identity as dealers or sellers. They want to be more socially acceptable and as sellers, they may not get respect from certain circles, so they then pretend to be buying for themselves. I consider this breed to be wounded personalities! However, we understand the difference between those who publicize themselves as collectors and those who prefer privacy and discretion.

> The mediator of the inexpressible
> is the work of art.
>
> JOHANN WOLFGANG VON GOETHE (1749 to 1832)
> German writer and pictorial artist

SIX
ATTENTION: CURATORS, CRITICS & WRITERS

Curating is an art. A good curator conceives an art exhibition and acts as a facilitator between the audience and the artists.

If your visitors do not 'get' the show or get it all wrong, they may wander around looking bewildered and leave with unhappy faces. It is the job of a curator to act as the messenger who delivers ideas from contemporary society. He needs to understand the audience, communicate well with both audience and artist, and lets the artist's work speak.

As a curator, you are also responsible to reserve exhibition space and fix dates. The job is like a film director's. You need to oversee every detail of the production, so be extremely organised and work well with others: it takes many skilled people to put on an exhibition. Try and make the experience as stress-free as possible by planning everything beforehand.

You can be an independent art curator and work with assorted museums, overseas galleries, etc. Working in one country is different from working in another depending on the social context, work ethics, etc. The audience and their interaction with the artwork is a foremost concern. Next time you organise an art event – be it a solo or group show – be sure to fully consider the powerful effects of curating an exhibition.

At Breathe Arts, we invite international curators to curate shows for our online exhibition space.

TAKE THE GUESSWORK OUT OF CURATING AND CREATE A STUNNING SHOW

There are many steps to putting on a great art show and all take careful thought, planning and time management. Get them right and your show will be far more spectacular than the sum of the individual artworks. Here is a simple process to put on an exhibition from start to finish.

GET INSPIRED
Start off by visiting excellent museum exhibitions and art events regularly to get a feel for the style of curating you wish to model for a particular show. Learn from the professionals by going to a significant art exhibition at least once every week. Keep your heart open and take risks.

SET A GOAL
Before you begin working on your own art opening, you need to write a fairly simple mission statement. What is it that you want to achieve through this exhibition? How will you communicate this to the artists, the audience and the team you are working with?

Think through every detail, leaving nothing to chance. This is the fun and creative part of the job! What is the purpose of your exhibition? Is it a survey show, a retrospective, a showcase of new talent, a cross-cultural exchange, an illustration of a theme or a topical issue? Before you get into the smaller details, think of the overall idea and theme for your exhibition. Is it in a traditional gallery space or in an alternative site-specific venue? Construct a visual dialog and attempt to put together an ambience for your show.

BRING ON THE ARTISTS

Carefully select the artists for your exhibition. This requires a lot of preliminary research on your part. Choose your artists and your curatorial context carefully. For a group show, choose a fairly small number of artists who complement or contrast in a way that makes aesthetic sense, that create a visual dialog that delights the audience. Decide whether the artists need to make new works (which add to your budget), or will you exhibit older works? You need to convey your message to the artists in an inspirational way, where your curatorial note motivates them to conceive works especially for your exhibit. Remember to clearly state any constraints upfront.

BUDGET

Allocate the right amount of time and a feasible budget that enable you to effectively contextualize the work within your given space. A curator needs to plan and procure the proper funding and this is one of the most challenging tasks, unless you are commissioned by a gallery or an institution. There is no set formula that works for all; there are various methods. As always, research is key here; you need to follow up any possibilities for receiving financial support. Seek corporate sponsorship. Involve the fraternity, local schools and neighbourhood organisations for extra support. You also need to set a budget for artists' fees or commissions, project fees, advertising, printing catalogs and invitations, shipping and handling, customs duty, framing, installing, lighting, opening expenses and overheads.

TIMING

Plan at least 12 months in advance, preferably longer if you wish artists to participate fully and to arrange all the necessary details. Spend at least 2 days organising the exhibition and giving it the cutting edge. Schedule your opening for an evening when the maximum numbers of people are free to attend. For example do not open a show in May in Mumbai, when the

summer holidays are on and most people are traveling. The peak of the art season is usually between September and February, so plan your important shows to open in these months. It may be helpful to work backwards from the opening date and schedule the needed steps. Set deadlines for each facet of the project and get in to the intricate details of your exhibition.

VENUE

Consider where the exhibition site is? Is it in a public rented gallery? If it is in a private gallery or a museum, what are the costs they will sponsor? Also consider whether you are working within a local venue or is your exhibition travelling overseas? How will the art works travel? Will the artists travel to install the works as well? Consider the shipping and insurance costs for a travelling show. You might also need to organise travel, accommodation and visas for visiting artists. Work with the gallery or museum staff to create a positive, productive environment for all involved.

Once you have a venue, walk through the space in your mind. Get floor plans and map out the layout in advance. Consider any structural changes to the space - like painting and building walls if required; and get necessary permissions well in advance. You also need to procure a wine permit license to serve alcohol for an opening at a public gallery space in India.

Spend time with all the art works inside the actual exhibition space at least a week before the show begins. Let them speak to you! Thematically different art works may require partitioning the work into different areas, like the rooms in a gallery.

SET-UP

Think like a Minimalist - Less is more! Art works need room to breathe. A general perception is that the more expensive and

exclusive the art, the less work is placed within a given space. The negative space around the art is crucial to the display.

Think about creating a unique experience for the viewer through this exhibition space. Here you have the chance to create the right atmosphere for the display. You need to think of an interesting dialog between the artwork and the viewer. Your aesthetics play a huge role. Create a logical sequence and a flow to the display. A private gallery is more open to allowing structural changes to their space than a public gallery. A gallery will have its own staff to set up any installations. For site-specific installation, art handlers can install a contemporary show in a gallery. If the artwork was shipped, the crates, bubble wrap and other packaging materials will need careful unwrapping to avoid damage.

Site installation is a key task when curating an art show. Typically, one week before the opening, you and your team need to install the works onsite, which includes the construction and painting of walls. The artists and assistants will install the artwork and the technicians will set up the lighting and technical equipment, but you need to oversee these steps.

Some well-curated shows that deserve a standing ovation for the sheer experience they created are the 'Pippilotti Rist' exhibition in 2012 at Hayward Gallery, London. A very memorable experience! At one point I stood in the centre of the main gallery and took a sweeping look around the space. This amazing show looked like a symphony of sound in which each video was a note! Another such powerful show was Anthony Gormeley's exhibition at London's Hayward Gallery in 2007. This show was a stunning display of scale, where life size sculptures of naked men about to jump from the top of buildings were installed all across the skyline of London; this engaged even common folk outside the gallery and all over the city there

was a buzz about this installation. No great exhibition just happens. It is the result of the curator's excellent, creative and painstaking execution.

DELEGATE

Make sure you are absolutely clear about who is responsible for delivering and paying anything, including inward freight, outward freight, installation, dismantling, curator's expenses, translation, catalogs, design, press, marketing, opening reception, so on and so forth. A curator needs to keep an eye on these extra costs.

It also pays to research the country's artists and audience to understand potential issues and your working environment. Will the artist and the audience understand what you are trying to convey? A good curator archives the social context to guide and engage the chosen audience and make the exhibition interesting for them.

COMMUNICATE

Writing well is another necessary skill for an art curator. You will need to publish a catalog, which is a great documentation and promotional tool that may lead to future projects.

Curators advertise in art magazines, hold press conferences, panel discussions and workshops at the opening and during their exhibitions. Also, telephone key people such as journalists and collectors whom you want at your opening. Hold a pre-opening press conference with press kits that contain texts explaining the show's concept, the list of artists and a CD of images. Say a few words and have the artists speak briefly as well. For good press coverage, provide journalists with detailed text, images and good sound bytes. This may include interviews with the curator/artist(s) for local media, commissioned pieces of writing, photographs, blogs and additional support/materials for the gallery.

The printed and posted art invitation and e-vite you know. Advertise the printed art invitation in newspapers, art magazines and on public transport, put up the e-vite on the Internet and broadcast announcements and schedule interviews on the radio and TV. Instruct the artists to stay near their installations to answer visitors' questions.

ORGANISE a panel discussion of the artists and other experts during the opening week when public interest is high. Involve local artists and students in the talks.

D-DAY
A grand opening is the result of a wonderful buzz; creating a buzz keeps people coming back. Begin the opening with a live art or music performance, and then introduce yourself, the artists and other significant figures to the audience. Serve well-chosen refreshments and h'orderves. Remember, a fun, exciting and memorable art opening will have your audience returning again and again!

Chapter 2

THE BEST KEPT SECRETS FOR COLLECTORS AND INVESTORS

**ATTENTION:
COLLECTORS AND INVESTORS!**

ATTENTION COLLECTORS AND INVESTORS!

The patronage for Indian art has changed many faces since its inception. From the times when royal courts acquired art to when industrialists and then corporations began collecting, Indian art has had many powerful patrons.

Acquiring art is a lifestyle statement for some, an investment decision for others, while a handful of philanthropists seek art to offer patronage to culture. Several different factors motivate different people to acquire art.

Acquiring a work of art should be for yourself, it should reflect you and your life. The price of the work you buy is not as important as the connection and joy you feel with it. Expressing your very own, unique story is what collecting is all about and hence each collection is as different and unique as its patronage.

Indian art today needs patrons, and this is actively sought from those with a passion for collecting and creating collections. Promoting culture needs passion-driven leaders at the wheel, and not only investors who trade for gain. Often the privileged have the vision to promote and preserve a nation's cultural heritage and it takes courage to follow through on a passion of this nature. All collectors in every era need to be appreciated for playing this essential, invaluable role for all the time to come. This is a tribute to all the collectors and their collections, which tell stories about them and their times and help preserve the heritage of a people.

ONE
ATTENTION: COLLECTORS AND INVESTORS!

HOW PASSIONATE ARE YOU ABOUT YOUR ART?

One distinction between a collector and an investor is a differing passion for art. A collector is passionate about the artist and in love with the artwork, and may almost worship it. An investor is passionate about the profit and price appreciation of the artwork. As a result the collector wants to keep the work and finds it hard to part with it, whereas an investor waits for an opportune time to sell his portfolio and collect his profit.

Before 2005, collectors bought Indian art masters for prices as low as Rs. 2 lakh to Rs. 5 lakh, (US$4,000 to US$10,000), and these have now gone up to Rs. 25 lakh to Rs. 50 lakh (US$50,000 to US$100,000). Now at under US$4,000, one may be unconcerned about any appreciation, but those entering these markets at US$50,000 or US$100,000 are forced to look at the investment aspect. They need to know which way the pricing trends will go if they put in such large amounts of money.

The galleries have given investors a lot of flak, and chosen to refrain from selling to them because they don't want their works flipped around at auctions, upsetting their pricing and control over the inventory. It is natural that they only want to sell to collectors but the pure patron variety of collectors is diminishing.

It is only the new billionaires who are buying for their museums. Others, who pretend to be collectors, are obviously trying to upgrade their social acceptability within the fraternity and avoid being shut out from buying opportunities.

To remain in a gallery's good books, they are seen at buying opportunities from time to time.

However, top of the roof prices have forced people to become investors because the choice is to either stop buying or continue value buying. Most buyers want value deals and not overpriced works; they want to acquire work when the prices are relatively low so naturally, they can participate in the upside. This is not a bad intention.

Here, we will address collectors and investors as one group, even though we understand that they are different in their intent. The collector wants to collect and patronize the arts, sometimes with a philanthropic intention, whereas the investor wants to profit by churning his collection often and at every opportune time.

CAN YOU SPOT THESE COMMON ART-BUYING MISTAKES? - Do not buy art until you read these facts

Buying art as an investment is all about the timing and the price at which you acquire a piece of work. Whether you bought it when the artist was unknown, or relatively unknown, or at his peak when his was the hottest piece, all this affects prices. Whether you bought on the way up, at the peak or on his way down determines the quality of your investment.

The Art Market is very trend driven. A group of top influencers control these trends in any given period. This group is made up of top galleries, artists, critics, curators, publications, auction houses, buyers and the world economies. All these forces align to create a perception that results in an upward trend. Then, they magnify with a significant global presence for the artist, which results in a peak before the downward trend begins. Markets are made of movement; there are three directions the market trends can move in, upward, downward or consolidation (stabilization).

This happened to the Contemporary Indian Art Market from 1995 to 2007. From 1995, prices for contemporary artists like Subodh Gupta, Jitish Kallat, Bharti Kher, TV Santosh, Justin Ponmany, Riyas Komu, Jagannath Panda, Atul Dodiya and Anju Dodiya were gradually moving upwards and reached an all-time high in October 2007, outperforming the Modern Masters who had taken an era to achieve these price levels.

Then the first signs of recession hit the United States in September 2008 with the fall of Lehman Brothers. Western Collectors and investors who had bought these contemporary Indian Artists suddenly withdrew their interest in light of the global slow down. The bubble burst unexpectedly and suddenly prices of the contemporaries that had shot up recently, came crashing down. We were in a downward spiral and are still recovering after the European recession.

Art funds were out of business as they had promised unrealistic returns to investors. No one foresaw this recession. Galleries saw a significant fall in high value sales worldwide and a drop in foot fall; some shut down galleries and cut their losses. One up side of the recession, however, is that it offers plenty of opportunities for collectors and investors chasing money.

The Modern Indian Masters were back in vogue. Indian masters that are a part of history are now available at affordable prices:

prices at which the Contemporaries were trading just some time ago! Hence in India, there was a sudden shift in buying trends. As people became risk averse, the masters were in demand and the low prices meant a potential upside.

Now in the next upward trend, collectors and industry forces are uncertain about the market's direction and about who will still be present in the upward trend and who will get wiped out.

My point? Buying into hype is a common mistake. Don't just believe hype, do research and talk to other buyers and galleries. If you don't know where to begin, join the Breathe Arts Art Millionaires Club and learn about art investments from professionals before you actually buy anything. If you want to be a golfer, learn how to play golf!

Similarly, if you want to buy and invest in art at the right price and the right time, then first spend time educating yourself about the market, prevailing trends, prices, etc. This is the only way to avoid expensive mistakes. Learning from buying, at auctions or at galleries, is an expensive way to go about things.

Even if you know the artists or the galleries, you need to be in the inner circle to get the best buying and selling opportunities and know who to buy, where and when before you take the plunge.

Knowing the artists and buying directly may not always be the best strategy because it lacks the added layer of market guidance. It may be worthwhile to learn even if you think you know it, because often, there are things that you know but do not do, or things that you said you would do, but did not do. This book is a good place to start for both: a seasoned collector or a novice, who can seize the opportunity to learn about the trends and the so-called secrets of the art world not apparent on the surface.

"HOW I MADE A $10,000 MISTAKE!"

We all make mistakes when buying art, especially early on, and then end up learning from our mistakes. I too started buying works by artists I felt strongly about and spent my income from other businesses on this passion for a long time. Let me tell you, since there was no guidance or guided model, I learnt from my mistakes, which were often expensive and time-consuming. If I had the option to figure out which side of the market I wanted to be in, and the option of learning about the subject with a guided exposure, the time taken to build value would have almost halved.

I could have saved huge amounts of time and money with the right knowledge on timing, the right artist, the right price and the right source. Hence I created these courses for art lovers, art enthusiasts as well as the veterans of the industry in a bid to speak to all and underline benefits for all.

Art has played the prop for many a lifestyle and luxury statement, home décor, aesthetic indulgence and many other extravagant ambitions. Art buying usually follows a series of other evolutionary stages representing the financial status of a typical individual. First a man buys a house, then he buys a car, then he buys a second car followed by a second house, then he buys art to decorate his walls, and when he runs out of wall space, he starts realizing that the art on his walls might be an asset, and starts looking at it with that 'investment' perspective and starts buying at auctions and uses storage facilities and then begins to sell some of his works. Some buy art to make a statement of arrival after they have achieved great success and have run out of everything else money can buy. Some because it helps them express their newfound status in society and it becomes a part of their lifestyle statement, a few others buy to support the

cultural heritage and give back to society, while many buy art to appease their vanities. Each of these stages define a specific buying trend or a specific buyer behavior. To give you some perspective, a man buying art simply to adorn his walls is not concerned about the market or the artist, he is just looking for a piece of home décor.

IF YOU HAVE ALREADY BOUGHT ART, THEN DON'T READ THIS. IT'LL BREAK YOUR HEART.

There are established price benchmarks that will break your heart if you have already overpaid for your art purchases, but read on so you can learn from your mistakes.

There are four categories of artists: the emerging, the developing, the established and the masters. The rule of thumb for buyers is: Emerging artists are those whose works should be in the range of Rs. 30,000 to Rs. 2 lakh (US$600 to US$4,000) for large 5' x 5' canvases.

Developing artists have a good primary gallery representation for 5 to 7 shows and their prices vary from approximately Rs. 2 lakh to Rs. 7 lakh (US$4,000 to US$15,000).

Established artists have a secondary presence and are available at auctions. Their prices for a 5' x 5' canvas should be between Rs.10 lakh and Rs. 25 lakh (US$20,000 to US$75,000).

Masters have a strong secondary market demand and prices for a significant work range from Rs. 25 lakhs to Rs. 1 crore (US$75,000 to US$200,000). Anything over this range means you

have overpaid and may not get that kind of value back from your sale in the near future. Then there are the blue chip works, which are rare works by master artists from their best periods. These come up for resale at auctions rarely and they would be in the Rs. 1 crore to Rs. 10 crore range (US$ 200,000 to US$2 million).

The only exception to this rule would be a unique work by a master from a rare and coveted period, one not found easily in the primary or secondary market, or works on paper. The prices established at auctions are sometimes not the true picture and could be slightly hyped. The highest recorded price for an FN Souza masterpiece at a recent Christie's auction was US$2 million (Rs. 10 crore).

A value buyer must know what range to buy in, what period, and who is genuinely in demand. A good way to keep track is to record auction sales and prices. Pay close attention to the lots brought in or the unsold lots and find out why they went unsold.

Usually auctioneers declare the reason as 'reserve price not met'. These lots could be acquired at distress sale prices after the auction. If you want to explore this territory, then track auctions and their results. If you do not have the time, you can specifically search artist-wise or period-wise or even outsource this job; many websites are happy to do this for you at a fee. A lot of free data is also available on the Internet pertaining to these auction results.

> Mistakes are painful when they happen, but years later, a collection of mistakes is what is called experience.
>
> DENIS WAITLEY (1933),
> American motivational speaker

TWO
ATTENTION: COLLECTORS AND INVESTORS!

HOW TO BUILD AN ART COLLECTION WITHOUT SPENDING A FORTUNE

One way to build a collection without burning in your pocket is by doing sound research or enrolling in an art club, where an inner circle of members gets access to buying and selling opportunities, for instance at The Art Millionaires Club.

If you do your research well and have real, not perceived, facts and figures by talking to many different sources like galleries, buyers, auction houses, etc, before you actually start buying, then you've eliminated chances of buying the wrong work of art, the wrong artist, at the wrong price and the wrong time. If you get these key factors in place, you must still check whether you are buying on the way up or on the way down. In the art market, there is no easy way to find this out without the guidance of a trusted, knowledgeable inner circle.

If you have questions or seek buying and selling opportunities, or are just learning about art and the market, this membership is for you. You need to be on guard against manipulative dealers and galleries trying to palm off unsold works. Be well informed about underlying market trends and thoroughly understand your motives for buying, pricing, etc. and stay away from hype to avoid expensive mistakes.

Another strategy in order to avoid spending a fortune on building a collection, is to buy emerging artists from top galleries with the advice and guidance of an inner circle. This limits your risks because established galleries will usually perform well, going by their track records. It is important to

learn from the insiders if and how strongly the promoters feel about an artist's work that interests you. This is the key to finding value within an affordable range. Within the parameters of what you like, look at good investments and avoid buying at the peak price.

To participate in the upward move in the next cycle, one strategy is to pick the top 3 artists of the top 5 galleries, and buy works from their second and third solos before the artists become a hot trend. Do not buy top artists when they have moved on to newer, hotter, younger trends. Copy the buying cycles of successful gallerists to participate in upward trends.

Another strategy is to buy a whole bunch of works from an emerging artist's portfolio at his first solo from a top gallery, that feels strongly about his work and may give you good value because they need sales or the turnover.

Alternatively, you can buy unsold works at distress prices after an auction is over. Here, keep in mind other factors besides price, such as provenance, quality, the artist and his timing in the market, and the market confidence he enjoys.

Yet another way is to buy work directly from an artist if you know him, but do ensure that he is at least represented by a decent gallery. However, this may not be possible any more because most artists have tie-ups with galleries and are not allowed to sell outside their contracts. This can be also unsafe, because you do not have the gallery's support and guidance for a future sale or for establishing authenticity, etc. While this may be cheaper, this could create doubts about authenticity later. It may be best to buy work at a primary market gallery.

In the case of masters, published works with strong provenance and authenticity certificates from top galleries help in firming up a future sale. Get proper documentation when buying and do not buy just because of an attractive price minus such documents. Published works have a better demand, carry more prestige and have proven provenance if required, when selling. So even if they don't come cheap, it could be worthwhile paying top dollar for such rare and published works.

HOW TO PROTECT YOUR INTEREST WHEN BUYING ART

When buying art, you need to protect your interest in three ways. First, research the price at which you buy, second, buy the right artist at the right time in the market cycle and third, get valid documents proving authenticity from the artist as well as the gallery.

If you are buying at an auction, note whether the work you are bidding for is outside the country. If so, you will pay additional import duties of about 15% to ship the work back to India. This varies depending on the country the work comes from and the final shipping destination. Import duties are payable on delivery at the port of landing. These too vary from country to country.

For example, with a Hong Kong or Dubai address, you can save on import duties applicable on shipping art into India. Interstate transactions within India attract a 2% Central Sales Tax against a C Form. Sometimes it makes economic sense to buy a work in your company's name against a C form to avoid a VAT of 12.5% that is charged on purchases made from a

Mumbai address.. Kolkata, for example, has no tax on art sales, so many Indian galleries have offices there to save on this tax. Additionally, there are freight and insurance charges added to every purchase.

Auctions charge a buyer's premium of 15% and shipping, handling and freight in addition to the hammer price at which you acquired the work. Most galleries handle the smooth delivery of the work to your doorstep along with these charges. When buying at www.breathearts.com, simply add the work of your choice to the shopping cart, and these charges will be calculated automatically based on the shipping address you registered when logging in and the work will be shipped to you anywhere in the world.

Ravindar Reddy

THREE
ATTENTION: COLLECTORS AND INVESTORS!

HOW TO MAKE A MILLION DOLLARS IN ART

There are multiple strategies to make a million dollars in art. Western markets are already at their peak and western masters are unaffordable for most people. In emerging economies, where the economy is in a growth cycle, their art may boom. BRIC nations, i.e. Brazil, Russia, India and China, are good places to start. Chinese art is already overblown in value and that leaves India, Brazil and Russia.

The strategies discussed here are universal and applicable to whichever economy you choose to play in. As I mentioned before, for the sake of convenience, we will refer to the Indian art market scenario, my area of expertise. However, you may successfully implement the same strategies in any other art market if you follow this advice word for word.

Depending on the size of your investment, there are two main strategies for buying art. People like to buy top works by top artists at the best prices because their risk is that much lower as they are buying known, established names. They know they can sell overnight if they wish to liquidate their portfolios. This can require large amounts of capital and a possible wait for one to three years for the investment to appreciate. Others like to catch them young and watch them grow. This just proves that there are different strategies for different types of risk appetites. In this example, your risk depends on the artist's name, the promoting gallery and their ability to excel in a competitive market.

Most galleries and promoters are investors themselves and hold majority stock of their artists' works. However promoters without a risk appetite are happy to invite other investors to buy their stock early. These are the opportunities that we can help you find.

Here, you are investing in emerging artists. The capital required is lower but the risk attached is higher and your return is spread over 5 to 7 years, depending on when you choose to exit. If the artist becomes a star, then you have hit gold and could make a million dollars on your investment, depending on the number of artworks bought. If he or his promoters run out of steam, then you may have to write off that investment and enjoy the work for its beauty instead.

The assumption that most collectors, investors and galleries work under is that out of the 20 artists they promote, even if 3 make it to the top 10 Indian artists ranking in the next 3 to 5 years, they are covered for the other 17 who did not make it, or who have an average run. Even within the chosen 20 artists in a promoter's inventory, it is a very competitive run up to the top 3.

The 'flavor of the season' changes according to the market's acceptance of a certain artist. There was a time when galleries or promoters could define these trends quite simply by the judgment of their own eye. Today, the market place is a huge and competitive space and demands many other volatile factors to work in their favor to turn their artists into stars.

Some of these factors are international representation and acceptance, fair and biennale participation, critical and curatorial acclaim, primary market demand and eventually, secondary market demand. All these determine and define a trend in the market.

The risk averse may not invest in younger artists as these are prone to more risk and many factors could go wrong. These investors may buy only masters or well established works at best value. Others without huge surplus funds to invest in masters or top contemporary artists could choose the other strategy and buy the top 3 emerging artists from the top 5 galleries. Both are good, depending on where you belong and you can mix and match strategies based on prevailing opportunities. At the Art Millionaires Club, we share all kinds of opportunities based on your membership level.

But, before investing, it is up to you to research which artists are in demand, and whether the demand is genuine. Follow the advice of someone trustworthy and also check with different sources before deciding. Use your discretion to test the validity of what is being told or sold to you. At the Art Millionaires Club, we can share our research and experience and find the right opportunities for you on an ongoing basis.

In terms of price, understand that each artist's work has a price range, starting from the price his works sold for at his first primary show, going up an average 30% per annum. That is to say, if his first solo show establishes the primary market price, then from there, each year it may be expected to grow 30%. The price depends on when in the cycle of his career you are buying his work, at his first solo show, even before that, at his peak or when he is already in the secondary market. This determines the artist's price at the present time. The price at which you acquire a work of art is everything in the world of art investment and appreciation, because prices may or may not appreciate from the levels you acquired. If you bought a work at the artist's peak, the scope for appreciation could be lower. If you bought it at the very start of the cycle, both the chances of appreciation and the risk are much higher.

I hope this advice helps you to understand that when you buy is as important as whose work you buy and from whom you buy.
In the event of buying masters, it is imperative you buy with top provenance from the top 3 galleries or auction houses or published works. Cheap deals may not always give you these. Future appreciation and sales depend on these documents. They will save time and resources at a later stage.

Earlier, collectors bought directly from artists to bypass gallery commissions. Today these works, when presented in the market, fail to win the confidence of a present day buyer who is paying top dollar and will demand excellent documentation. Without these in place, your status as a collector needs to be reputable and non-controversial in the market and absolutely clean for the buyer to feel confident about your provenance. Foggy provenance fails to win buyers' confidence and the work loses value.

Finding good value deals is by far the most daunting task in this type of investment as in any other. Finding the right work by the right artists from the right period at the right prices is the key to successful art investing. The way to research is to find out the top 10 master artists, the top 10 contemporary artists, the top 10 galleries and the top auction houses in the market for your niche. Then research the prices, the gallery prices, the primary and secondary demand supply equations and the benchmark prices from their sales records. This information will help you establish a link in prices, market movements and the price for a particular artist. Most auction catalogs display the provenance of the work and these provenance details will give you a sense of current owners and the type of people who collected this artist's work.

FOUR
ATTENTION: COLLECTORS AND INVESTORS!

THE TRUTH ABOUT BARGAIN HUNTING. HOW TO GET GREAT DEALS ON YOUR ART PURCHASES

Finding great deals can be daunting, but they will be worth our time and effort. One good way to begin is by looking at online portals like www.breathearts.com, where we have already pre-negotiated prices clearly and transparently displayed under each work to make your process simpler.

First you get to view all major galleries' stock on their individual pages; this promotes transparency and credibility, and is a great way to browse the entire market at one shot in one place. You can compare prices, find the best deals across galleries, even search artist wise. You can see if different vendors are selling the same artist's works at different prices and pick the one that best suits you. This, to my mind, is by far the best buyer centered service in the entire art industry. It is a great place to look for the best deals on what's available with who and at what best price, a most complete way to research the market.

The most effective way to get the best value is research, research and even more research. Understand market perception, the demand for the artist or work you wish to buy, their primary and secondary market prices, the galleries representing them and the range of pricing with different vendors. Once you have these facts in place, you can command fair prices.

HOW TO FILL GAPS IN YOUR COLLECTION

Engage an art consultant to review your collection and check for gaps. You may need a valuation report. Breathe Arts Advisory Services can help you understand and fill gaps, get rid of pieces that do not fit in and acquire new rare pieces by the same artist, perhaps from a different period, to complete the sequence in your collection. Other times, it might be about finding the story line in your collection and curating it from time to time to get a different perspective. Breathe Arts helps with this as a one-time or an ongoing project.

FAQ: TAKE THE GUESSWORK OUT OF SELLING ART

HOW DO I ARRIVE AT THE RESERVE PRICE FOR MY ARTWORK?

For a seller to arrive at a work's base price, he should take his original buying price and add the various costs involved in making this sale, for example, auction charges, taxes, shipping etc. Then, deduct this amount from the desired selling price to see the profit needed in this transaction.

If you need liquidity in a slow market, you may be happy to get just your investment back plus a 10% profit. If you are not pressed for liquidity, then wait until you can make at least a 30% profit in the transaction. Setting the price depends on how quickly you need the cash. In a slow market, bidders scout only for good value propositions. For instance, if you bought at the peak in 2007, then you may find yourself in an odd spot, because the prices have come down since. You may not even recover your buying price.

In such a scenario, you have two options-either wait until you get your price, which might take 2 to 3 years, or sell now at a loss. You could, hopefully, recoup your loss in another trade by buying something cheap and selling it profitably after 6 months or a year. If you choose to sell at auctions, then the auctioneer helps you set the estimated price for your artwork based on comparable works and the current market for a particular artist and the specific work. The seller needs to communicate his reserve price, i.e. below which he is unwilling to sell. Sellers thus remain in control of their artworks since they permit the auction house to sell only if this reserve price is met. The seller is not obliged to sell unless the reserve price is met, even if there are multiple offers. This way, you may get offers but reserve your right to sell if the bids fail to meet your expected reserve price.

If you ask for too much, chances are the sale won't go through, if there are already many opportunities for buyers. If you are asking for too much, dealers, auctioneers and buyers will tell you so when you ask why something is not selling.

Recently, most auction houses have suggested very low estimates on their catalogues, sometimes even lower than the reserve price to kick-start the bidding. However, if the work fails to reach the reserve price, it will be taken back and the auctioneer will say 'Reserve Not Met'. In any case, unless bidders really want something or feel they have found good value, they won't even be tempted to bid.

CAN I ARRIVE AT THE SALE PRICE BY COMPARING PRICES IN OTHER CURRENT AUCTION RESULTS?

Yes. Set the price of your artwork by comparing it to different current auction results for similar works by the artist, (in terms of subject, size, period, condition, media, provenance, etc), as well as the primary market price (the price at which galleries are selling the artists' work).

However if the artist is alive and if comparable work was unsold, then definitely don't use that price as a benchmark. Come down 5% to 10%, depending on how long that artwork has been on the market. So, just because a work is priced at a certain amount and it is still available, doesn't mean that is the sale price. Look into how long it has been on the market and whether it compares to your artwork and research recent sales.

ARE WEB SITES ACCURATE IN DETERMINING THE VALUE OF ARTWORKS?

Websites that offer price comparisons are a good place to get estimates for a particular artist's work. However, they are often plagued by unrealistic seller expectations. At Breathe Arts, we pre-negotiate all prices before putting the art works up for sale.

DO I NEED TO PAY FOR A VALUATION REPORT BEFORE PUTTING THE ARTWORK ON THE MARKET?

Paying for a valuation prior to putting your art on the market is really not a bad idea. In fact, it is a great idea.

At http://www.breathearts.com/HowToSellAtBreatheArts.aspx, we do free valuations when you put up your artworks for sale on our private sale section. Check out http://www.breathearts.com/BreatheArtsPrivateSalesRooms.aspx to register for invitations to our Private Sales Rooms.

NEGOTIATIONS IN A SLOW MARKET

WHAT WOULD BE A REASONABLE OFFER?

A reasonable offer by a buyer is one that a seller will accept or at least make a counter offer to.

DO NEGOTIATIONS END WHEN I ACCEPT AN OFFER?
Accepting an offer on your artwork is not the end of negotiations; it is, really, the start! After this, the viewing is arranged wherein the buyer views the artwork, inspects it physically and may find several issues that need clarification, such as provenance, location or condition of the piece. That is the next phase of the deal and this could initiate fresh negotiations.

WHEN COMPARING OFFERS FOR MY ARTWORKS, IS PRICE ALL THAT MATTERS?
No. Price is not the only issue here; contingencies are huge and determine which way the deal swings. Check the buyer's financial standing and whether he is in a position to close, and whether his mode of payment suits you. Also consider applicable taxes, consultants' and auctioneers' commission, etc. Figure out if he is a first time buyer or a seasoned one? This makes a big difference in the transaction and how the buyer handles it. His consultant, representing gallery, auction house or confidant may also have a say in how the deal goes.

SETTING THE RIGHT PRICE

IS THERE ANY BEST TIME TO PUT MY WORK ON THE MARKET?
The best time to sell depends on which artist's work you want to sell, its period, the provenance and the prevailing market trend for that artist. Markets fluctuate in prices and trends for artists. Sometimes, some artists are in demand and at other times others, so gauge the peak of these trends and track the market demand before putting up the work for sale. Otherwise you may be left with unsold work. Check with the auction house or a consultant about which artists are currently hot and you will learn when to sell.

HOW CAN I READ THE MARKET?
There are different perceivers of the art market: auction houses, galleries, artists, plus dealers, consultants and investors. Auction houses like a turnover; artists and galleries like to see prices going up, while investors like to see prices going up or down very rapidly. The investors normally tend to get it right. So if they say the market for a certain artist is going up, chances are it is probably a good time to sell.

DO I NEED AN EVALUATION FROM THE AUCTION HOUSE AND THE CONSULTANT?
Auction houses and consultants tend to work on a turnover basis - they need to keep selling. So if you sign up with an auction house or a consultant, they will give you a price at which they know they can sell the work in question easily. So, do a bit of research to ensure you are maximizing your asking price.

WILL MY SALE BE AFFECTED BY MARKET FLUCTUATIONS?
Sellers are often shortsighted when it comes to selling their artworks. If they hear the market is going up, they tend to wait and think that if they wait another six months, they'll get more money. Don't get too tied up in market fluctuations. If you want to sell and there is a reasonable offer, then just sell.

WILL PEOPLE BE PUT OFF BY A HIGH PRICE?
My twelve years' worth of experience says, setting too high a price will put buyers off. Consultants and auction houses are there to find the market value of your artwork. Therefore, pitch the price at more or less the right level or even slightly lower. If you put it too low, you will get a lot of people looking at it and you may be in a situation where you have a firm offer or more than one buyer. Thus, you will find the true market value of your artwork.

PRIVATE SALES EXPLAINED

WHAT IS THE ROLE OF AN ART CONSULTANT?
When it comes to selling your artwork, art consultants begin by evaluating the artworks, and then preparing the details, including dimensions, photographs, and possibly an estimate for each work. They then work out a marketing strategy, which will include advertising your images on their online spaces, emails, and network. They will also organize viewings. They sometimes ask you to do this, but often attend to them when you are unavailable. Finally, consultants negotiate with buyers to, hopefully, get you the best possible price.

DO I NEED AN ART CONSULTANT TO SELL MY ARTWORK?
No. Many people think they are obliged to use an art consultant, but this isn't the case. You're absolutely free to sell your artwork privately, on your own, without a consultant, or with the help of a portal like Breathe Arts, which can help you sell your artwork privately and discreetly.

WHAT ARE THE BENEFITS OF SELLING ARTWORK PRIVATELY?
The main benefit of selling your artwork privately is that you save on a consultant's charges and on high auction premiums. This can be considerable and it is the largest single component in the charges for selling your art. Most auction houses charge between 12% and 20% as a seller's premium and art consultants charge between 5% and 10%. So, to sell a work of US$200,000 (Rs. 1 crore), the minimum commission will be US$10,000 to US$20,000 (Rs. 5 lakh to Rs. 10 lakh). The maximum buyer's premium at the auction will be US$24,000 to US$40,000 (Rs. 12 lakh to Rs. 20 lakh). Thus, depending on which way you sell, your commission might vary from Rs. 5 lakh to Rs. 20 lakh. This way you can save significantly

if you sell work privately. If you can route the transaction directly in the personal name of the artwork owner, you can even save the 12. 5% VAT for the buyer.

IS IT IMPORTANT TO ADVERTISE MY ARTWORK ONLINE?
Yes. Art consultants say that in an unregulated market, their most important marketing tool now is the internet; when looking for artwork, the first thing many people do is to log on to the internet.

IS IT A GOOD IDEA TO POWER MY OWN WEBSITE?
When it comes to selling your artwork online, it's not a good idea to make and design your own website. Even if you put up a website, it is another ball game to optimize it and get truckloads of traffic. There are enough sites that manage online sales well and put your works up for free.

HOW TO LEASE WORKS AND GENERATE PASSIVE INCOME?

ATTENTION:
ARTISTS, COLLECTORS AND GALLERIES

If your inventory has artworks and you are currently paying for storage, we could reverse this cash flow situation and lease your artworks to corporate offices, hotels and airports and generate passive income for you. Simply click on Art Lease under Services on www.breathearts.com/HowToSellAtBreatheArts/ArtLease.aspx and upload the works there. We will get in touch with you as and when we find clients interested in leasing your works.

> An artist cannot fail; It is a success to be one.
>
> — CHARLES HORTON COOLEY (1864-1929)
> American sociologist

Chapter 3

THE BEST KEPT SECRETS FOR ARTISTS

ATTENTION:
ARTISTS!

ONE
ATTENTION: ARTISTS!

WHO WANTS TO BE A STAR ARTIST?

As an artist, mediocrity is your worst enemy. Mediocre artists are broke. You need to rise above the average scale to realize your own highest potential to succeed. Anyone with an 'Overnight Success' story usually has a decade of work behind it, so build your skills and an extraordinary body of works that showcase the very best that you are capable of.

To be a star artist, you need to be a genius, and then you need to get your works noticed by the right people in the right circles. Once you've got the attention and mind space of the insiders who matter, they will take you to the next level if they feel strongly about your work.

There are artists and there are artists. And there is no second-guessing who has a genius talent and who is ordinary. In this crowded and competitive field, there is very little room at the top, and unless you are in the top 10 positions, don't even think about making money. There is little income to be made from art exhibitions, except for those totally committed to excellence. People need to be touched by your works. Your works need to have an impact on them for their simplicity, integrity, scale or potential. Your art is your medium to show the world your vision, the highest you are capable of.

The only way you stand a chance to qualify for the race is if you are willing to think big and do whatever it takes to join the top list of artists in your industry. Alongside, you need to sustain the quality of excellence in your work for a prolonged period of 7 to 10 years without expecting any major gains. Winning the race

calls for everything you have got, and above all cultivate persistence-because with that skill alone you can outlast a majority of your peers.

As you build a stunning portfolio, a growing network of peers and a growing fan base, you will have more people who could be potential customers. With a steady stream of customers, all other aspects will fall into place over time, and eventually it will get harder to fail and easier to generate income.

It may sound tough, and it is, but the good news is that most people in this field are not as serious about art as you need to be to succeed. Rest assured, they will give up within a year or two and go back to other hobbies only to be replaced by people with even less experience. There is a lot of churn at the bottom.

In that sense, the art world is akin to the film industry. There are millions of wannabe actors but only a small percentage is committed to becoming a truly outstanding super star. Most people will get a little role here and one there, and dream of great success but, at the end of the day, they'd rather take the easy way out; they don't have the temperament and the persistence of those at the top. These people are not your benchmark. If you stick with your skill and demand excellence from yourself consistently for 3 years, you will be way beyond the majority and they will never match your talent.

If you are unwilling to commit to long-term excellence, don't even dream about being at the top. The top 1% get paid because they are the ones who have put in the time and the years and have done what it takes to get there. It is true that the vast majority of artists are not making much money, and frankly, that is because they are not that great and still others do not have the patience or inclination to get to the required level of greatness.

If you swap fields every year or two, you will not be in a position to build a financially sustainable practice. You may switch if you really want to, but there is a price for doing so.

So ask yourself: Do you love your art so much that you will invest 10 years working full-time with little or no compensation? If you have any doubts about making that kind of commitment, then you better move on to the next best thing. Let's say even if you are willing to make that kind of commitment, or already have committed a few years to the field, do you have the support of the right factors in the industry aligned in your favour to take you to your dream place?

To begin with, you need a truly outstanding portfolio coupled with the support of a high profile partnering gallery, influential media relations, the right collector base, critical and curatorial acclaim, top artists endorsing your work, a good network of friends and fans, international biennale and fair representations, museum and important collection representation, the perfect timing in the market, and, atop it all patience and persistence.

This is just a reality check before you consider a career as an artist. If the vast majority of artists in your field won't become financially successful, then your best might not still be enough to bypass the fate of majority and you need to do whatever it takes along the way.

There are many uncertainties involved, and don't try to take it on alone; this is a collaborative field and the support of the insiders is absolutely imperative to take you to the top. Success takes everything you have and most often it needs more than your skills in producing an excellent body of work. However, everything else follows this body of works, and if this is really absolutely a work of genius, it will be that much easier for other things to fall in place. Then it will only be a matter of time that all these other forces will align in your favour.

Hence it might be a good idea for an artist to be a great marketer of his own works, and place his own works in the right spaces as he goes along his career. Being shy about promoting your art will hurt you financially.

Show your work to anyone who might be interested. If you want to become a successful artist, you need to get your art, not only onto people's walls, but also into their eyes, ears, minds and hearts. If the art lies hidden in your studio or buried on your hard drive, don't expect it to create any buzz. If you aren't willing to do this, don't expect your art to leap into the market by itself.

Focus on visibility first and don't worry much about generating income. A good strategy for creating visibility is to give your work away for free to the people that matter. If you give your work for free, and people don't seem to appreciate it, consider the possibility that your work (a) isn't very good, or (b) isn't what people want. This happens to just about everyone, everybody falls and not just the first time either. Keep refining your creative output until you produce something that people appreciate enough to share your enthusiasm for.

Once your visibility is high enough, then start charging for your work. If you can gain visibility and sustain it in the long run, then it's much easier to generate abundant income. To gain visibility in a crowded market place, consider selling online.

HOW TO BECOME AN INSIDER

I reiterate that to be termed a successful artist, you need to be at the top of your game, so do what it takes to get into that space. The business of art has a significant social bent; insiders have it much easier than those outside, or even those on the periphery. So if you're looking to break in, or be at the center of things, aim to be part of the insider's clique.

Financially successful artists are generally happy to share their stories, so make every effort to meet such people and hang out with them. Join clubs, exhibitions, attend fairs, biennales and conferences and find other ways to socialize with the successful. It's not too difficult, but it requires effort, communication skills and a willingness to learn the tricks of the trade.

When you meet such top artists, aim to be friendly, interested, and respectfully curious but assume an equal standing as a creative human being. Artists are generally very comfortable discussing their work, so a great opener is to ask a specific question about their work. Feel free to pick their brain, but know when to stop.

A passive approach will get you nowhere; push yourself to go outside and meet people. No matter how enthusiastic you are about your work, if you step out of the studio now and then, it's not the end of the world!

Successful artists in any field typically know each other. They may not spend a lot of time together, but they often meet because they move in similar circles. It is wise to prepare yourself for this opportunity, so it eventually feels normal.

Networking with other professionals is also good business practice. In any field, it's difficult to get much exposure for an unknown artist, but if you have friends who will help to get the word out, it will become a possibility.

You may praise or be influenced by someone else's work, but it is imperative that you think about your own message, your unique voice, your concerns and your vulnerabilities with your current body of work. This connects your inner space with the outer work. It is important to think about and articulate this in your voice. Don't expect people to just drop into your studio to commission work. Your message needs to be heard by the industry insiders. If you are not confident about your communication skills, join a class or ask a friend to interview you.

Use every source at your disposal to get your work and voice out there. Think of unconventional new ways. Create videos of your work and post them on You Tube or other social media networking portals. The world is going digital, and more and more visibility is being gained online. Consider using online space creatively to get your message across. Your website can share your vision with the world.

HOW TO MAP YOUR CAREER AS AN ARTIST

You may be good, but in order to be successful, you need to be outstanding. And in order to be outstanding, you need to put in the years. Don't be in love with your own art to the extent that you begin to settle for mediocrity; instead, be honest with yourself. That way, if you realize that you don't have what it takes to reach the top but are still serious about making it big as an artist, learn the required skills, identify your weak points, and work on overcoming these in the next 5 years to become truly outstanding. Don't fool or trick yourself with laziness or shortcuts because they will lead nowhere.

Find a way to articulate your concerns and message in a clear, unique way. Seek help in getting your message out to the world

at large and communicate it to the media. Don't try to do it alone, even if you are a great communicator, because most people who think they can do it on their own, seldom go all the way. Simply engaging a PR agency is not good enough, the art world is very competitive. Take things in your own hands and find ways to communicate your unique vision. Sharpen your own public speaking, marketing and PR skills to hit the top. If this does not come to you naturally, take time to learn these skills.

Find a good gallery to represent you because backing from a strong gallery goes a long way in establishing your reputation. If you don't possess the skills required to become a star on your own, don't expect galleries to work on you because they may represent 20 other artists. Remember, galleries don't make successful artists, they only work with artists who already possess the skills to become successful. If you're on that list of 20, you are still competing with the other 19.

Remember, your job and major efforts begin when a gallery agrees to represent you! Unless you influence your market, the gallery cannot do much to influence it. Galleries can support you or show you how to start but, if the market response is not too great, they will focus all their energy and resources on those who have a strong market appeal.

Once a gallery comes on board, many artists feel they are covered. Not so. All that's happened is that you moved up a couple of notches because you are now competing with the top three in the gallery, and no longer with the mediocrity outside. Leaving your promotion and communication entirely to the gallery is not the best way to do things, but most artists fail to understand this. They almost stop working once a gallery represents them, and assume that the gallery will carry them forward. This is a huge mistake. You need to polish your skills and work even harder to build on your success and top their

other 19 artists. Get honest feedback about what works and what doesn't before you go to the market place, because you will rarely get more than one chance to make a decent first impression. Join the Art Millionaires Club on www.breathearts.com and polish these skills with the right knowledge over time.

As I mentioned before, success in the art industry is all about its inner circle and getting the right people to see you, hear you, like you and rate you. If you can find your way with them, then you can make your way in the world quite easily. So build a rapport with writers, critics, curators, galleries, investors, collectors and consultants who matter. Once they approve of your work and are happy to work with you, you will find it easier to reach the inner circle. You need to influence this niche. Unless they see you and treat you like an insider, you will not progress.

The social aspect aside, you also need to add to your portfolio year after year. If you have a solo show with a good gallery and a few shows at other important institutions, it adds weight to your CV. When people turn to the last page of the catalog, they want to see not just your work, but where you have exhibited, which collections or galleries represent your group shows and which gallery is promoting your solos. They want to know that gallery's reputation and acceptability in the marketplace. Most importantly, your promoter's profile enhances your profile and vice versa.

Sometimes artists are faced with difficult choices: they need to start somewhere and so they pick up any opportunity that comes by. But I would not recommend this. Do not rush because it is better not to have shown than to have done it with a shoddy gallery. Most successful artists know how to make the right moves, taking only strong opportunities and letting go of others. Most successful artists and galleries are quite picky

about what they show or represent. But it is important to understand this and be discerning each time a gallery makes an offer. A mediocre gallery only shows mediocre artists, while one with refined tastes will show artists that match their standards. Sales are very important for financial success. Without sales, there's no income, and it is hard to sustain yourself. If you maintain strong sales, then even if you mess up almost everything else, you will still have a sustainable art practice. Strong sales make up for careless mistakes!

A top Bollywood star once said he accepts some acting roles for the money and others for his soul. Sometimes, you too will create works purely for the sheer joy of creativity while at other times you create what you need to boost traffic and generate income. You are always free to create art for art's sake, even if it won't pay the bills. You need to decide!

Ideally, before starting a new project, ask: Who would most appreciate this? If you create art to sell, then spend more time creating art for both sheer pleasure and for selling. If you want to get paid, then create art to sell. Determine who will buy your work and why. Once you build up sales, there are likely to be buyers for anything you create. This is the most rewarding aspect of being a topnotch artist! Selling is treated as a discipline unto itself, but for a serious artist, selling is an integral part of his creative process.

If you want to create art to sell, it's wise to know why someone would actually buy it. If you create work that aligns with what people want, then selling is largely letting people know you have something that appeals to them.

If, on the other hand, you have to do a lot of convincing to get people to actually buy, then the problem is most likely the art itself.

BE A PATRON

Selling need not be pushy or manipulative; while you need to respect the place money has in your artistic efforts, don't put it on a pedestal. There is a difference in creating art to sell and selling yourself short in the run for money. What I'm trying to say is that you need to build your sales strategy in the production of work itself.

A habit worth forming for artists is to buy the art you appreciate with your own money. If you find the work overpriced, don't patronize it. When you support other artists, it reinforces the belief that you deserve to be supported.

When I look at my own collection, I not only see works that I love, but also see a list of artists that I've helped support financially. It is comforting to know this.

Being an avid supporter of other people's creative work can motivate you to increase your own income. I have a sizeable collection of art, this tells me that the more money I earn, the more I can support other creative people.

How readily do you buy art that you appreciate? If you wish others to respect and pay for your work, then have the integrity to show this respect to other artists too.

M F Husain

TWO
ATTENTION: ARTISTS!

HOW TO HANDLE CRITICISM

In any artistic field, more people criticize than create. Criticism does not always imply negative judgment. You need to be able to look at criticism objectively to use it to your benefit. If you get emotionally involved based on what a critic says, you lose the unbiased advantage required to use what is being said in your favour.

As a critic, I think it is almost natural to have an opinion on almost everything. In other words, if I don't have an opinion about something, I consider it to be unworthy of my judgment, or it is something so crude that it just doesn't affect my sensibilities and passes my eye unnoticed. You don't want your art to be unnoticed, so from this perspective, even if the criticism is negative, the critic is admitting that the work has had some impact, albeit negative! Forget those who approach art with undercurrents of bitterness, resentment and envy.

An apt summary of the relationship between artists and critics can be seen in Teddy Roosevelt's 'Citizenship in a Republic' speech from 1910:

'It is not the critic who counts, not the man who points out how the strong man stumbles, or where the doer of deeds could have done them better. The credit belongs to the man who is actually in the arena, whose face is marred by dust and sweat and blood; who strives valiantly; who errs, who comes short again and again, because there is no effort without error and shortcoming, but who does actually strive to do the deeds; who knows great enthusiasms, the great devotions; who spends himself in a

worthy cause; who at the best knows in the end the triumph of high achievement, and who at the worst, if he fails, at least fails while daring greatly, so that his place shall never be with those cold and timid souls who neither know victory nor defeat.'

Constructive criticismmay come from other artists, people who understand what it's like to play in the area. Genuine criticism is helpful. Sometimes it helps by providing a specific idea for improvement. If it makes sense, then use it, but don't give it more weight than your own opinion. If you want to be better, pay full attention to your work.

Abandoning criticism doesn't mean letting go of reason and becoming blind to areas where you should improve. Drawing attention, even negative attention, to the work may still benefit you with extra publicity!

Here's some more from Roosevelt's speech: 'There is no more unhealthy being, no man less worthy of respect, than he who either really holds, or feigns to hold, an attitude of sneering disbelief toward all that is great and lofty, whether in achievement or in that noble effort which, even if it fails, comes to second achievement. A cynical habit of thought and speech, a readiness to criticize work which the critic himself never tries to perform, an intellectual aloofness which will not accept contact with life's realities - all these are marks, not as the possessor would fain to think, of superiority but of weakness.'

Remember that history remembers great artists, so in the long run, even negative critics can ultimately serve the artists your long-term interests.

HOW TO CONTINUE PAINTING WITHOUT WORRYING ABOUT PAYING YOUR BILLS

Most artists have concerns about ongoing, regular expenses without an ongoing, regular income coming their way. It is worthwhile to invest time and learn how to manage money, even if you don't have too much of it. Habits like saving money and managing it well pay off in the long run. Remember, the amount may well be insignificant, but the habit is important.

If you learn to manage small sums of money, you show the universe your ability to manage what you've got and it will send you more, and soon you will be able to manage larger amounts as they come in. You are only preparing for the success that you know is on its way!

Calculate your monthly recurring expenses and your income. Write down the exact amount of money you need every month to live a satisfying life. Passive income means money made without working for it daily. Learn to manage your money so it generates some interest income that will eventually grow and take care of your month-to-month expenses.

If you find ways to generate an ongoing passive income, you can focus on gathering other needed skills to become outstanding without financial worries.

An emerging artist may make little or no money from sales. You may need to simplify your life, cut out all unnecessary expenses and save at least 10% of your earnings every month.

Put it in a fixed or a recurring deposit every month, which gives you a 10% return per annum. If you invest just one hundred rupees everyday, that can give a compounded interest of over a 100 times in the future. The amount might seem paltry but compounding interest can give wonderful results. Attached below is a table of how you can invest a 100 INR daily to earn an interest income. Get smart with your finances!

If you are a developing artist and make some money each year from sales and a show, you need to generate additional streams of passive income to support your practice and your family.

If you are already at the top, then reinvest your money to get higher returns on your investment. A financial planner may be useful for you.

If you manage money in this fashion, you'll be surprised at how dramatically your spending habits change for the better. Inculcate these habits and learn to be free of financial worries.

If you manage funds this way, you will soon become an excellent money manager. Most successful people are either excellent money managers or have very good financial advisors to help them save and profit.

If you start with these basics, you will soon realize that you too can manage money well, an essential trait for every artist - beginner or master.

AMOUNT OF 100 INVESTED ONE TIME

Return on Investment (per anum)

YEARS	2%	5%	7%	10%	11%	12%	15%	18%	20%	25%
1	102	105	107	111	112	113	116	120	122	128
2	104	111	115	122	125	127	135	143	149	165
3	106	116	123	135	139	143	157	172	182	212
5	111	128	142	166	173	182	212	246	272	349
7	115	142	163	201	216	232	286	352	405	575
10	122	165	201	272	300	332	443	605	739	1,217
15	135	212	286	448	521	605	918	1,487	2,007	4,247
20	149	272	405	739	902	1,102	2,007	3,857	5,454	14,816

IMPACT OF COMPOUNDING INTEREST

IMPACT OF RECURRING INTEREST

AMOUNT OF 100 INVESTED EVERY DAY

Return on Investment (per anum)

YEARS	2%	5%	7%	10%	11%	12%	15%	18%	20%	25%
1	36.866,43	37.425,27	37.804,08	38.381,66	38.577,04	38.773,53	39.370,95	39.980,53	40.399,79	41.451,67
2	74.477,58	76.769,24	78.349,00	80.799,80	81.639,03	82.489,70	85.112,07	87.843,79	89.728,18	94.672,11
3	112.848,51	116.130,26	121.833,47	127.678,22	129.707,39	131.778,57	138.254,02	145.143,97	149.962,04	163.002,66
5	191.931,40	207.322,51	218.488,96	236.742,05	243.259,03	250.006,49	271.723,98	295.864,44	313.450,59	363.372,07
7	274.241,63	305.894,48	329.667,76	369.949,27	384.748,40	400.297,70	451.878,47	511.877,38	557.290,29	693.668,84
10	404.047,82	473.525,31	528.529,16	627.036,99	664.853,54	705.503,09	846.875,02	1.023.412,12	1.165.264,30	1.631.122,65
15	638.472,08	815.330,63	968.482,37	1.270.480,48	1.395.522,96	1.535.390,17	2.064.282,22	2.812.495,72	3.480.099,99	6.054.114,02

HOW TO AVOID COMMON MISTAKES WHEN PUTTING UP YOUR EXHIBITION

There are a bunch of mistakes that artists fall prey to when putting up an exhibition.

The first is that they don't pay any attention to marketing the exhibition.

The second mistake is doing it entirely by themselves, when they have no expertise in forming lists, reaching out, PR and sales.

The third mistake is they have no unique message to communicate about this exhibition or about themselves.

The fourth mistake is they have not thought out strategies for reaching the maximum number of people and for bringing in a good audience, especially after the first day.

The fifth mistake is they don't express, share and market their message effectively to the maximum number of people.

The sixth mistake is not understanding that they are spending Rs. 500 to Rs. 1000 on each of the 100 friends and family who come for their exhibition.

Here is a break up of costs when putting up a typical exhibition at Jehangir Art Gallery in Mumbai:

Rs. 40,000 on one week's rent
Rs. 10,000 on catalogs and invitations
Rs. 10,000 on couriers
Rs. 10,000 on shipping and food and drinks

This total of Rs 70,000 does not even account for the one year of your life spent creating the works and the material used. That makes your expenses over Rs. 70,000 if you add up all the columns. Assuming you spent only this, if 100 of your friends and family show up at the opening, you have spent Rs. 700 bringing each friend and family member to the exhibition.

Supplementing a physical gallery show with an online exhibition and marketing would give you a reach of tens of thousands of people at the fraction of the cost; thus improving the probability of visibility and sale.

Statistics say that 90% of all art exhibitions sell up to 20% of their works in an average scenario. Most artists incur losses when they realize nothing has sold. It's disappointing, but you need to build this possibility into your project costs and marketing expectations.

HOW TO GET YOUR ARTWORK INTO A PUBLIC AUCTION

Once you have a strong demand in the primary market, something that you achieve after sold out solo shows with your galleries, and a strong enough secondary market presence, you will be upgraded and welcomed with open arms by auctions houses.

A meaningful secondary market presence means a strong demand for, and exchange of, your works among collectors and investors, when your name sells and you command this status If you try to manipulate this process and speed it up before your time is ripe, then you risk falling when the market falls. So it is important to move up slowly but steadily on a firm foundation backed by genuine market demand.

To get into an auction, you need to have had several successful primary shows, international representations at art fairs and biennales, and critical and curatorial acclaim. Your works need to be a part of many important collections and museums across the world. A regional or local presence is not good enough: you need a global presence to reach the top. Today, the world is much smaller and the whole world is now your canvas.

Moreover, these days, new, unconventional media can get your voice out and make an otherwise lengthy process relatively short. Online media is a powerful tool to tap art markets. You can articulate your unique message through this powerful medium in a way that's far more effective today than it has ever been. There are people out there who want to see you, hear you, and understand you, and online media can connect you to them.

Once you become a familiar name well established in your niche, and in great demand then you are a star!

HOW TO GET A SOLD OUT SHOW EVERY TIME !

You already know that a successful show requires you to articulate and communicate your unique message or voice across several media, and to catch the interest of the right people before you actually show your works. Public relations and focused marketing by your gallery can sell your show even before it opens. However, it is equally essential that your market be ready for people to buy your work without actually seeing it, just because of your name.

The way this works is simple. You could trickle your works one at a time in the market in the run up to the show, thus selling one work each month and then keeping them all for your opening. Result, an opening with an all sold out show! Based on inquiries at the opening, you could take requests for commissions. Then, continue to create and sell works individually over the course of the year right until your next exhibition. Optimum sales are impossible if you are creating work until the minute your show opens.

This is not to say that you should be too available. If your work is cheaply and readily available any time of the year, why would people await your solo show? Why would your gallery focus on you and your market?

To create an all sold out show without being stretched too thin, plan the perfect sales strategy with your gallery. It's simple economics; an all sold out show is nothing more than managing the demand and supply of your work in the market. If you manage the supply so that the demand is perceived to be higher than the supply, then any work that comes up for sale will be lapped up by the hungry market. The secret strategy is to create a market hungry for your works in confidence with your gallery.

If your work is available for sale with every person in the industry, the supply exceeds the demand. Hence most successful artists, galleries and collectors, at the risk of being snooty, will not sell works, just to keep the market hungry. They whet the market's appetite before opening the show, so that it is a sellout. If you want to achieve that, then you have to manage the demand-supply equation in the market. Some artists do not care about selling all their works, and are happy to create their piece and leave sales to the gallery. If you feel that you, an artist, are above sales, then you will never have an all sold out show.

Then there is another type that sell outside their mutually agreed contract and in group shows with other galleries, etc, but that ruins their demand-supply equation. You cannot sell out of your studio if you are working with a gallery. Either produce works in a trickle or, if you produce a lot at one shot, have the capacity to hold onto your works until the right time.

If you need money, you can't take a shortcut and sell quickly. You need to consult your gallery closely before doing any such thing. If you lose patience and start selling randomly, at all possible outlets and prices, then your gallery will have less interest in your market.

Discuss these strategies individually with your promoting gallery and see how they feel about your market. Work closely to develop and build your market. Place your works strategically on selected walls over time, as agreed with your gallery.

If you go out of turn or sell out of your studio and do other foolish things, thinking your gallery will never find out, you are very wrong. Not only will they find out, they will also stop going the extra mile to push your market. So don't slit long-term success for instant gratification.

THREE
ATTENTION: ARTISTS!

HOW TO KEEP YOUR DEMAND AND PRICES ON THE UPSWING

To give it to you straight, if you flood the market with an oversupply of artworks, the demand and prices you command are likely to suffer.

This is especially true if you are not at that point in your career, where, if you increase the amount of your art in the market, buyers will eagerly absorb it. Part of your current success is likely due to the way your market is structured. In other words, only a limited amount of your artwork is available through maybe one or two galleries and that's that. The key is to control at any given time, the amount of artwork on the market and the number and location of the galleries that sell it. If you produce artwork faster than it sells, don't flood the market. Assuming you don't have a substantial collector base, the more galleries that offer your artworks, the more negotiable your price. As a result, your retail prices may come down.

Collectors like to believe they are getting something special when they buy art, not something they can get anywhere, any time and with little effort. To get a steady selling price or to keep it on the rise, maintain a degree of exclusivity. Your artworks should not be too easy to acquire.

Even though you have plenty of art to sell, add only one gallery at a time, monitor the impact on your market, and do what is necessary to make sure new galleries don't compete with your current ones. As for the one or two galleries you already work with, reconsider how important they are for selling your art, and perhaps even more important, for maintaining your profile.

Increasing the number of galleries that sell your artworks is a good idea as long as you're careful how you do it. Wait long enough between new additions to note how your overall market is affected, especially that delicate balance between the number of artworks you have for sale and the number of people interested in owning it.

If, at some point, you become really famous and can hardly make art fast enough to satisfy the demand, then at that time you can go after lots of galleries everywhere. After that, the trick is to make the situation stay that way because you don't want to be lopsided in terms of supply.

ARTISTS WHO MAKE ART FASTER THAN IT SELLS

The more artworks you have on the market in comparison to the size of your collector base, the weaker your prices tend to be.

If the buyer base begins to diminish, galleries will spend less time selling your artworks, less time keeping your name in front of the public, and you will become less of a frontrunner with both galleries and the marketplace. Discuss the details of your online profile with your galleries and make sure everyone understands who gets to sell what.

Also, never sell artworks out of your studio at prices lower than gallery prices. There will always be collectors who cut out the middleman and they will only increase as your reputation grows. It is best not to sell your artworks directly when galleries represent you or else they will focus less on you and more on other artists.

They'll keep doing what they do now as long as your shows continue to be successful. To keep things that way, make sure they approve of any career moves. Some galleries may drop you altogether. Do not upset them!

If an occasional piece of your artwork comes onto the secondary market priced substantially below what it sells for at your galleries, seriously consider buying it back or contacting a gallery or collector to buy it. A gallery approaching another gallery with a business proposition about your work generally carries more weight than an artist approaching a gallery. If for some reason, you can't buy back secondary market pieces, never badmouth the sellers.

If you put too much artwork on the local market through new galleries, something you could do easily if you make art much faster than it sells, you risk making it too easy to get, thus increasing competition between galleries and, in the end, compromising your status at both your main galleries. You may get whatever prices you consign the artworks for, but the galleries may undercut each other at the retail level in order to move some artwork.

Telling people that your artworks do not yet have the right look or medium or are too old is worse than letting them sit unsold.

Your best tack is to look for new galleries in other parts of the country. Your two galleries will likely lose sales to these new galleries and may oppose this increased exposure. If spreading yourself too thin compromises their current success in selling your artwork, they'll spend less time selling it and, here's the important part: less time promoting you as an artist whose work is worth owning.

Basically, the more active galleries are in promoting you and keeping your name top-of-mind in public, the more concerned you must be about keeping them happy. Allow the galleries to deal and thus minimize confusion, disagreements or misunderstandings over who gets to sell what, where and for how much.

For example, if you have 50 serious collectors and 400 works of art on the market, those collectors will be inclined to shop around and bargain. The further they are from your two current galleries, the better.

The single most important tip for all art sales: Pre-qualify your buyers before every exhibition. Before you even put up your exhibition, you need pre-qualified buyers i.e. to know who will buy and why. If you plan a show with 20 works, you need to pre-qualify at least 100 buyers to have a successful show.

HOW TO PRE-QUALIFY YOUR AUDIENCE - The most important lesson to learn in Sales

There is no point in trying to sell a body of works to anyone who comes by; they are unlikely to buy it and you would have just wasted your efforts and hopes. Pre-qualify buyers each time a work is made and pre-sell if required. Rethink your practice if there are no takers because there is nothing worse than running in the wrong direction enthusiastically. Be convinced about selling each work as a part of your strategy even before you create anything.

Pre-qualifying basically means having a clear list of people who are most likely to buy at a certain price, no matter what. If you don't have this built in, wait until you do and then start to create work. It may seem sad to reverse the process of creation but if you put up exhibition after exhibition with no sale at all, you may be out of the game even before you break in. Talent is all very well, but selling is also a very important part of your shows.

HOW TO GET AN ENTHUSIASTIC RESPONSE – Even critical acclaim – every time you show

This one is quite easy if it is all you want. The art world is filled with enthusiastic audiences who gladly show up to fill a space. Getting many people on the floor is not very difficult if you couple effective networking with cutting edge works and good food! Your friends and family too will fill up the space, but is that the purpose of your exhibition? To show your works to your friends and family?

I am assuming most artists will respond to that question with a resounding 'No!' Even so, it is precisely what 90% of openings are about. So much money, time and resources are spent on people who do not matter to the actual sales. How about changing this sequence and organizing a little talk, a walkthrough or a small interview with a critic or a curator at the opening? How about expressing your unique message and connecting with your audience? Articulation is the keyword to interest critics and curators in your work.

You might think that your job is done after finishing a painting,

but your best may not be enough. Be willing to go all out and do whatever it takes. So how about giving some serious thought to engaging your audience meaningfully at the opening?

Articulate your process intelligently, emotionally or spiritually, whichever way works to communicate your experience to your audience. You have to get out of your comfort zone and think like them if you want them to engage with your work.

Critical acclaim comes from sharing your process, your intent, and even your vulnerabilities with a critical and curatorial audience. No guesses for figuring out who these might be and how to engage them from the very beginning of your creation instead of bringing them on towards the very end! How about listening to them speaking at other openings and understanding what works for them, what makes them tick? Then you can make meaningful and genuine contributions before jumping into an impulsive frenzy of creation.

Can you reverse your order and first survey the market to see what is working or not, hear people, and research unless you are convinced you are a genius and need no second thought before creating a show? Creating a body of work is a serious production, which takes up time, money and resources - so do include some market research and understand the industry and its workings before plunging in. Be aware of the challenges in front of you and don't approach the field on the basis of a naïve creative impulse.

Raise your standards by first seeing, understanding and absorbing wisdom and accept market research as a part of your creative process before building a body of work. That is the mark of a star artist!

FOUR
ATTENTION: ARTISTS!

HOW TO TRIPLE YOUR SALES

My sincere advice to artists is that they should spend 20% of their time creating and 80% of their time marketing and managing their art business to be successful. This is a sticky situation that all artists face because what they love doing most is making art, rather than being in the business of selling it. Most feel that it is the job of the gallery to do the sales, and while this is true, galleries have 20 other artists in their stable whom they need to promote. The only person who can spare the time to promote your message and create the right buzz around your works full-time, is you! Also the gallery will focus more time and resources on those who are already performing at peak levels and have a demand in the market.

So it is really up to you to assume responsibility for your own marketing and create sales strategies in consultation with your gallery to keep you on top-of-mind recall in the market. After all, how can any artist expect his business to be successful if no one knows about his work? The prolific and successful American artist, Andy Warhol puts the whole Art versus Business dilemma into perspective. We can all learn and follow his art business operating philosophy. He said, "Making money is art and working is art and good business is the best art."

Artists also need to use innovative online media to promote their works on iPads, blogs, You Tube videos etc. Think of the time you spend doing this as another expression of your creativity, through which you can take advantage of the different, innovative media.

Run through this checklist to ensure you are doing the best you can to promote your work:

Are you taking advantage of social media to make contacts, promote and build your brand?

Are you using PR sites to promote your events, shows and sales?

Have you identified your target market and analyzed how to reach it successfully?

Do you have a website that displays your art wonderfully?

Do you have an ongoing email marketing campaign that exposes your work to the decision makers in your target audience?

Do you have a blog or online newsletter that drives traffic to your website?

As an artist, are you spending a majority of your time marketing and promoting your work?

If you spend twice the time and effort you spend on marketing today (and stick with it), you will see more traffic, more inquiries, be in more shows and eventually make more sales.

If you try to reverse the figures, and spend only 20% of your time marketing, you will be unable to reach and sell to your target audience. Try doubling your time to 40%, then to 60% and if you spend 80% of your time promoting and selling your work, recognition and consequently, success is bound to follow.

FIVE
ATTENTION: ARTISTS!

HOW TO COMMUNICATE YOUR UNIQUE MESSAGE

Most artists are often out of touch with the dynamics of their creative process. Take two identical paintings of the same size and type. Imagine that one follows an inquiry into the challenges of life and the other is a study in blue. One comes with an explanation and the other comes with nothing but a price. Buyers will want the one with more, not the one with less and not at all the one with no information.

People need something to connect with the work, the context in which the work was created, the reference of context in the artist's career, the social context and the personal context for the work to connect and engage with the piece, and to be touched and moved by the vulnerabilities that the work brings up. So it is important as an artist to articulate the process of your works for people to engage with your story and connect with you. All this information buried in a catalog essay might not do the trick, unless people read. You need to speak about your work, walk through your show with a talk or share your inspirational poem or symphony or whatever it took you to get to this day. People connect with their emotions and if this bond is missing, you might not hold the highest place in a viewer's heart. They need to be touched by what they see, by what they hear, by what they read, and this is the experience you need to create for people at your opening.

There are many ways to articulate your creative expression. One is to reconstruct your career forward from the time you

first began painting. Contemplating the course of your artistic existence is another approach that always seems to work. Just take one finished artwork and reconstruct its story from conception to completion as best you can. Or, start at the present and deconstruct your career backward.

Choose from these options and write down the progressions of events, your current work, and your life as an artist. If you are challenged about the nature of your work, you will run around tight-lipped, with little or no sense of purpose.

The more interest you generate, the better you can understand and talk about your art on a variety of levels and connect with your audience.

The only way to articulate your message clearly is to have a firm grip on your art making process. The more integrated that understanding, the better you will do it. The artists whose works you see in the best galleries and museums know in intricate detail what their process is about, what they're doing and where they're going.

The more successful the artist, the more the artist is written and talked about, the more information is available about every aspect of his life and work, the more his story continually unfolds. The more information available - like documentation, explanations and consequently, analysis and understanding - the more successful that artist.

You might find it tough to introspect but the potential upside is well worth the effort. It is possible that you may not even think or reflect on what you're doing while you're doing it. In an altered state of creative impulsiveness, you may be on autopilot and your art somehow happens: it begins, it ends.

If you are worried about how you might explain yourself, or articulate your message here are a few questions that might help you get started in the right direction.

How do you start making art?

Do you start at a regular time?

Do you have a routine?

When do you make art?

Does it follow a specific inspiration?

What do you listen to while making art and does it influence your work?

One common situation is that artists make art in an altered state of creative impulse. The overwhelming majority of artists create art purposefully, not impulsively; you need to introspect to get a sense of direction and purpose about your own career.

You can only engage your viewer to the extent that you are engaged. If you have no idea what you're doing or its significance, you can't realistically expect anyone to care beyond liking the way your work looks. If you want deeper engagement from your audience, you need to have a deeper, more purposeful direction about your art works yourself.

SIX
ATTENTION: ARTISTS!

HOW TO SELL ART FROM YOUR STUDIO - NINE TIPS THAT WORK WONDERS

For artists who do not yet have a strong primary gallery representation, here are some tips that can help you market your artworks like an expert.

ONE. When marketing art, artists are rarely successful at selling from the studio. Take the time to show buyers what they want to see and communicate your process about what went into creating the work. You could have a computer screen showing your collection, previous exhibitions, artist's statement, credits, awards, an updated portfolio etc. When greeting potential buyers, make them feel comfortable and welcome. Keep printed material readily available about your curriculum vitae, exhibition history and other relevant information.

TWO. If your buyer truly expresses interest in having a conversation, engage them as an artist, not as a salesperson. Talk to them about yourself and your art works, and why you do what you do. Avoid lecturing and do not be confrontational.

THREE. Keep in mind that traditionally, buyers and collectors are used to seeing artworks in a finished minimal gallery setting. A cluttered, dimly lit studio makes it difficult to assess your work. Arrange your studio such that you clearly reserve a space for finished work to be displayed. Arrange this section like a gallery because this will make buyers more at ease while viewing your works.

FOUR. Don't make assumptions about what buyers are looking for, as they might be interested in an older work or something entirely different from what you assumed. Show them what they are interested in and not what you want them to buy. Try not to force your views or influence the buyer to go with your way to thinking.

FIVE. The more opportunities you have for people to see your work, the more opportunity you have to sell additional works of art. Try to sell to buyers with a wide range of budgets. Even if they have a modest budget, but have expressed interest, try to find something suitable for them.

SIX. Price all your works clearly before allowing buyers to see them. If you are unclear about your pricing, expect the same from them about whether to buy your work or not. Don't try to price your work on the spot as it leads to different prices between competing buyers. The downside is that most buyers talk to each other and will find out if you offer different prices to different individuals.

SEVEN. Allow a few hours daily or weekly for buyers to visit your open studio. Clearly post this on your door. One habit worth forming is to have open studio hours or regular business hours from your studio, so people can come and view works. If you are in a shared studio environment, then maybe you could have a collective time for all the artists to have open studios for a couple of hours daily and communicate this clearly to all who visit.

EIGHT. Working in shared studio environments might be better to draw more buyers to your studio, rather than working in individual studio spaces where collectors have to come and find you. If you are established and already have a name for yourself, people will come looking for you, but it might be easier for people to find you if you were present in one large, shared

environment. Chances of people finding you by accident in this environment would be far greater than those coming specifically to look for you even if you are established. You could have a small studio gallery in one of these shared environments where people can come see your work even in your absence, or you could appoint someone to show them your space. You need to think like the buyer who has limited time in a certain city or area and will most likely go studios that are visible. I know artists like to think that people will find them in the forest if they are known and that may be true for some, but if you place yourself in the high traffic zone you might have more visibility and top-of-mind recall.

NINE. Pasting a little statement on your door also may generate interest. A shared studio environment is like a competitive booth environment at an art fair, but it goes a long way in collective marketing and attracting leads that were otherwise not known to you.

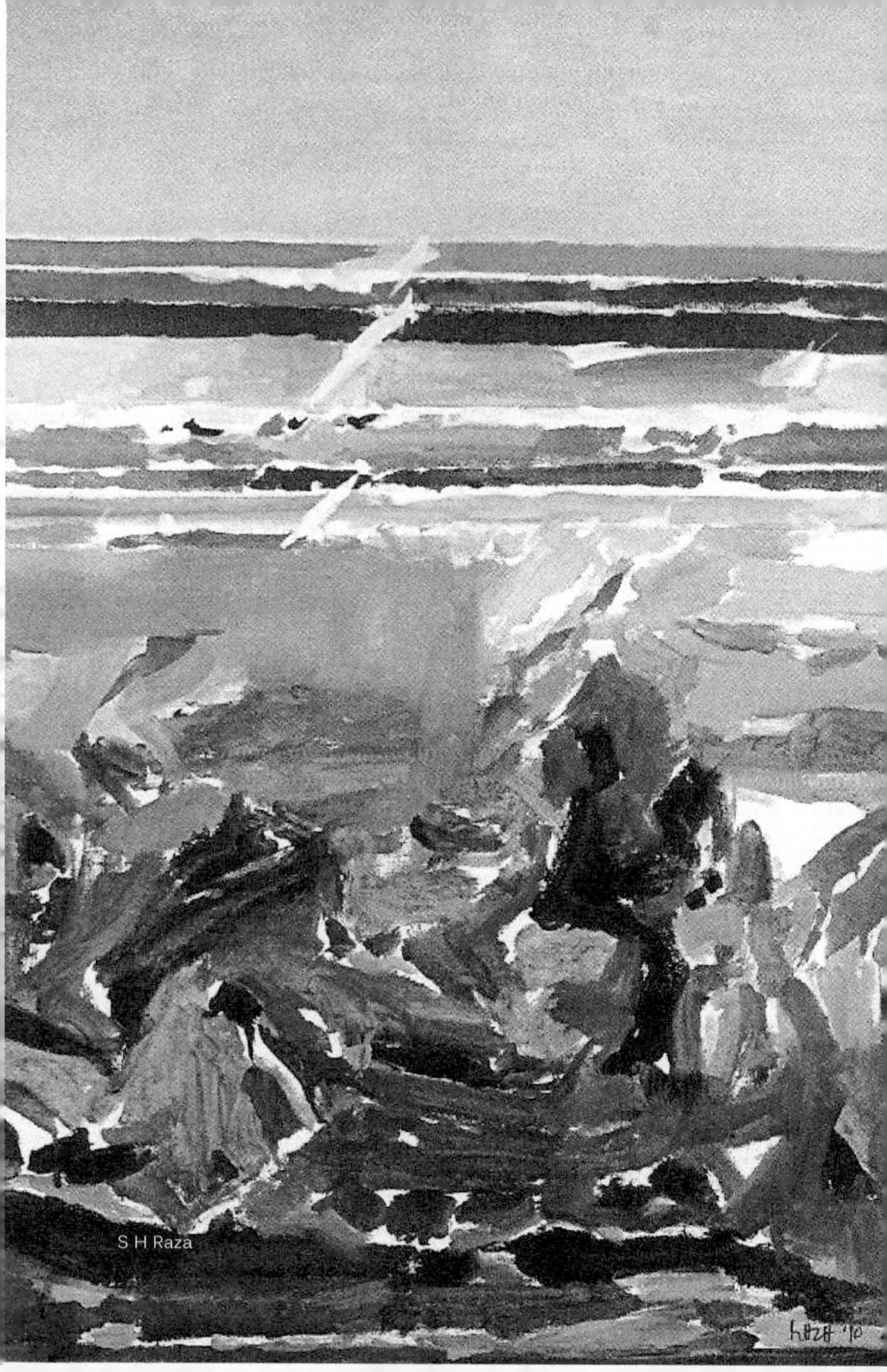

Chapter 1

ATTENTION
ART GALLERIES, CONSULTANTS
AND INSTITUTIONS

What Breathe Arts can do
For you?

THE BEST KEPT SECRETS FOR
ART GALLERIES, CONSULTANTS AND INSTITUTIONS

HOW TO CREATE AN EXHIBITION CALENDAR THAT GETS STAR RATING, PUBLICITY AND EAGER BUYERS

We can carry your exhibition online and promote it to our well-established markets as well as to our huge international database.

Visit
http://www.breathearts.com/AdvertiseWithUs/AdvertiseyourExhibitionPosterOnOurHomePageEventCalendar.aspx.

Also
http://www.breathearts.com/UploadYourExhibitionOnOurExhibitionSection.aspx and opt in to get started.

HOW TO CREATE AN EXHIBITION CALENDAR WITH ALL SOLD OUT! SHOWS

Breathe Arts can help you target your exhibition, invitations, artists and gallery profiles to a wider, art specific audience. We will send your business profile, your artists' profile, your exhibition calendar and invitations to 50,000 pre-qualified, art-oriented people on our database on an ongoing basis.

Visit
http://www.breathearts.com/AdvertiseWithUs/AdvertiseYourExhibitionPosterOnOurHomePageEventCalendar.aspx to opt in and get started.

We can also help you to market your exhibition to an art-specific global audience by advertising it on our event calendar on our

home page, which reaches almost 2000 relevant visitors. In our exhibition section, you can show and sell up to 20 works at a fraction of the cost of putting up a physical exhibition.

Visit:
http://breathearts.com/AdvertiseWithUsAdvertiseYour ExhibitionPosterOnOurHomePageEventCalendar.aspx.

And:
http://breathearts.com/AdvertiseWithUs/UploadYour ExhibitionOnOurExhibitionSection.aspx to opt in and get started

HOW TO SELL YOUR ARTWORKS PRIVATELY IN SECONDARY MARKETS.

Breathe Arts can help you gain visibility for your artists and your gallery on the Breathe Arts Exchange. Here you can sell your works with your own gallery name displayed and buyers can reach you directly, for year round sales, at a fraction of the cost of getting such targeted traffic to your own websites.

Visit
http://www.breathearts.com/BreatheArtsExcahnge.aspx
to get started.

We can also help you sell your top quality works privately or publicly. This private sales service helps you achieve the best prices discreetly through our network of buyers and affiliates.

Visit
http://www.breathearts.com/ConsignYourWorksForSaleToThe BreatheArtsPrivateSalesRooms.aspx to get started.

Alternately, we can assist Platinum Members of our Art Millionaires Club with investors as well as collectors for your artists and exhibitions and build a strong secondary market for your artists with our inner circle members.

Join
http://www.breathearts.com/ArtMillionairesClub.aspx
to get started.

HOW TO ATTRACT VISITORS TO YOUR GALLERY EFFORTLESSLY

There are multiple ways in which Breathe Arts can bring footfalls to your exhibition calendar. One way is to join the annual Platinum Membership at the Art Millionaires Club every year. This is a community of art lovers, enthusiasts and buyers.

There are two types of memberships: Gold and Platinum. As a gallery with an annual Platinum Membership, you have the privilege of a tie-up with the Art Millionaires Club. The Club will invite its select members to your special art openings through the year. This privilege alone may be worth your while to become a Platinum Member and attract more buyers to your space. Other privileges include discounts on e commerce on Breathe Arts services.

Visit
http://www.breathearts.com/ArtMillionairesClub.aspx
to enroll for membership.

Some other useful links worth checking out are:

http://www.breathearts.com/BreatheArtsExchange.aspx
to sell your works on **Breathe Arts Exchange** with YOUR gallery name displayed under each artwork. We have an option for buyers to reach you directly all year round. This exchange allows you the privilege of your own online gallery page on www.breathearts.com, where buyers can find you by doing a search on 'search by gallery', along with other galleries, at one place all year at a fraction of the cost of bringing this traffic to your own website. Platinum Members may put up unlimited number of works for sale at an introductory price.

http://www.breathearts.com/AdvertiseWithUs/AdvertiseYour ExhibitionPosterOnOurHomePageEventCalendar.aspx
Also
http://www.breathearts.com/UploadYourExhibitionOnOur ExhibitionSection.aspx to advertise your show online on a monthly basis. We can send your exhibition invitations to our database of 50,000 people who go to global art fairs regularly. If your gallery has 8 shows a year, you could at least advertise your important shows with us and let us send invitations, booth announcements and artists' profiles to our database on an ongoing basis. Even if you were having an exhibition physically elsewhere, advertising it on our event calendar on the home page and running it as a for display and sale exhibition on our exhibition section will only supplement your online marketing and sales.

http://www.breathearts.com/AdvertiseWithUs/Announce YourExhibitionOrEventToOurDatabase.aspx for galleries with 8 to 12 exhibitions a year that would like to outsource their mailing lists and invitations through another art company. You could supplement your own list with our sending service or simply letus do it completely 8 times a year. This way you don't waste precious time on operations when you could focus on sales. Even if you have access to some people on our list, it could be

more efficient to outsource this painstaking work to us, leaving you to manage sales. This could save on in-house resources and the time taken to oversee these processes. This is ideal for small and medium sized spaces and events and an absolute must for large important events and fairs.

http://www.breathearts.com/AttentionArtists/HowToSellAt BreatheArts/FixedPriceOnlineSale.aspx to churn your inventory every month and give all the works in storage a chance to be seen and sold to new audiences.

'OBVIOUS' SALES SECRETS FOR ART BUSINESS OWNERS AND CONSULTANTS

The Breathe Arts Affiliate Program invites people to join our network that enables you to make a passive income discreetly and comfortably, just with your iPads. Join the Breathe Arts Affiliate Network and access 600 works in our inventory as well as private selling opportunities to sell to your circle of friends and buyers. Without the headache of setting up your own business, this is the best way to earn passive income comfortably, anywhere in the world.

http://www.breathearts.com/JointheBreatheArtsAffiliate Network/General.aspx to opt in and get started.

Chapter 2

ATTENTION COLLECTORS AND INVESTORS

What Breathe Arts can do For you?

THE BEST KEPT SECRETS FOR
COLLECTORS AND INVESTORS

THE TRUTH ABOUT BARGAIN HUNTING: HOW TO GET GREAT DEALS ON YOUR ART PURCHASES

The Breathe Arts Exchange on *www.breathearts.com* is the single most powerful source to find artworks displayed by most vendors and galleries with their contact details in a single place. All galleries are present online and you can search for artworks all year round. This gives buyers an edge over the market as they can search several galleries and look for best deals on artists they are interested in across galleries without wasting time visiting each gallery.

FAQ: PRIVATE SALES EXPLAINED

1. Selling through Fixed Price Online Sale: This service lets you sell from our online gallery all year round for an unlimited period. We charge a 16.5% commission on sale from galleries and 33% from artists. All you need to do is visit *www.breathearts.com* and click on "how to sell at breathearts" and go to the fixed price online sale and upload your artworks with their details and it will automatically come to us for approval; upon approval the system will send you an agreement to accept electronically and once you accept it will come back to us; once we accept, the same will automatically upload in our online gallery.

2. Selling through Breathe Arts Lease: As part of a fixed price sale on Breathe Arts Online Gallery, you automatically get the option of making your art works available for lease. So this can be a good way to generate passive income from your inventory. We will discuss the lease rentals with you when we are interested in leasing your works. To avail either of these two options,

visit
http://www.breathearts.com/HowToSellAtBreatheArts/ArtLease.aspx to opt in and start uploading.

3. Selling through Breathe Arts Private Sale: This service caters to collectors, investors, galleries as well as artists who have a strong secondary market presence. At Breathe Arts Private Sales, we have a global network of interested buyers and consultants and manage your sales quickly, efficiently and discreetly. Private Sales is a flexible service offered to sellers, eager to sell their artwork privately, for getting the best offers and a quick turnaround sale without the complications of a public auction. It combines the best of both options: the auction and private sales. The works remain in a Breathe Arts Sales Room for a week and offers are invited from a set of pre-qualified buyers. The highest bidder over the course of five days has the opportunity of buying the work. Thus, we make it perfectly possible for you to sell your art privately at the same time inviting offers from buyers.

4. Selling through Breathe Arts Exchange: This is a paid service to display your art works with your own contact details or your gallery's name on the site for a small fee. Buyers can search by ⌧gallery name' or ⌧artist name' on Breathe Arts Exchange. So you can choose if you want buyers to reach you directly or through us.

Visit
http://www.breathearts.com/BreatheArtsExchange.aspx
and get started.

Chapter 3

ATTENTION
ARTISTS

What Breathe Arts can do
For you?

THE BEST KEPT SECRETS FOR
ARTISTS

SHOW YOU HOW TO ATTRACT THE RIGHT EYEBALLS TO NOTICE YOUR WORK - IN 5 MINUTES!

Breathe Arts can help you announce your show, reach the right audience, advertise your exhibition on our home page, and help to sell your exhibition from our online exhibition platform, even if it is happening elsewhere.

Visit
http://www.breathearts.com/AdvertiseWithUs/AdvertiseYour ExhibitionPosterOnOurHomePageEventCalendar.aspx

Also
http://www.breathearts.com/AdvertiseWithUs/UploadYour ExhibitionOnOurExhibitionSection.aspx to opt in and get started.

SHOW YOU HOW TO MAKE A GUARANTEED SALE - IN 25 MINUTES

Get your own online gallery on Breathe Arts Exchange and sell works with your own web link and gallery name displayed under each artwork. We let our buyers email you directly through a link (See CONTACT artist/gallery) under each artwork displayed with your gallery's name at a fraction of the cost of setting up your own space. We allow people to browse our inventory with a Search By Gallery option. You can have your own gallery page on the Breathe Arts Exchange.

Visit
http://www.breathearts.com/BreatheArtsExchange.aspx
to opt in and get started.

GUIDE YOU TO SELL YOUR WORKS ONLINE AND MAKE EXTRA MONEY

Our email announcement service reaches over 50,000 of the world's most important art buyers, critics, galleries, museums, institutions, art press, magazines and art fair going audiences. To be on our newsletter or to send your profile, booth or exhibition/invitations and information to pre-qualified audiences, sign up on *http://www.breathearts.com/AdvertiseWithUs/AdvertiseYourContentOnOurNewsletter.aspx*

You can also advertise with us on *http://www.breathearts.com/AdvertiseWithUs/AnnounceYourExhibitionOrEventToOurDatabase.aspx* to opt in, and upload your content.

ACKNOWLEDGEMENTS

I would like to thank many people who have inspired me, have helped me gain understanding of the Industry over the years and have been my mentors along the way. In particular, I would like to thank Shilpa Shah, Dabiba Pundole, Sarayu Doshi, Kekoo Gandhy who helped shape my early understanding of the industry. I would like to thank T Harv Eker for his inspiration and help in defining my purpose and premise for the book.

I would like to thank artists, galleries and collectors for their faith in Breathe Arts. In particular I would like to acknowledge the help and support of Alex Mandossian, Samira Sheth, Ashvin Rajagopalan, Rajesh Punj, Julia Ritterskemp, Manvinder Dawer, Shanti Chopra, Sangita Chopra, Ranjana Steinreucke, Geetha Mehra, Aarshiya Lokhandwala,

Ina Puri, Nevil Tuli, Renu Modi, Reena Latt, Peter Nagy, Pallavi Kotak, Roshini Vadehra, Arun Vadehra, Khorshed & Dadiba Pundole, Mamta Saran, Maithili Parekh, Aradhana Somani, Sangita Kathiwada, Anil Dharker, Brian Brown, Susan Hapgood, Shefali Malhotra, Atul Dodiya, Ravneet Gill, Sharada Dwivedi, Padmini Mirchandani, Baiju Parthan, Yogesh Raval, Dilip Jhangiani, Meera Ahuja and Vadehra Art Gallery on my journey this far.

I would like to thank Panna Saroopa of Hindustan Times who helped edit and proof read the book. I would like to thank Swapna Vora for her painstaking efforts to proof read the book. I would like to thank all the people who worked at Breathe Arts and believed in my vision over the years.

Above all, I would like to express heartfelt thanks to my husband Kumar for his constant and loving support.

"
Art is not a thing; it is a way.

ELBERT HUBBARD (1856-1915)
American artist and philosopher

"

THE ART MILLIONAIRES CLUB

For taking your first step towards financial abundance through Art Investment we would like to reward you and one guest with an exclusive invitation to attend the Breathe Arts 'Experience Art' event. At this event, you can learn how to transform your Art exposure to a profitable one.

To download your invitation and register, visit: www.breathearts.com/artmillionairesclub or call +919821104904

www.breathearts.com

www.ingramcontent.com/pod-product-compliance
Lightning Source LLC
Chambersburg PA
CBHW071013200526
45171CB00007B/102